The
Nine Muses

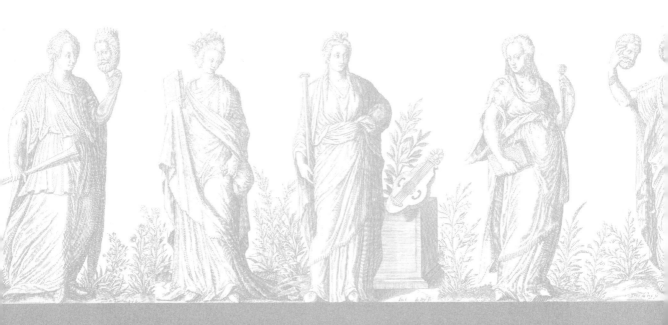

the
NINE MUSES

A Mythological Path
to Creativity

Angeles Arrien

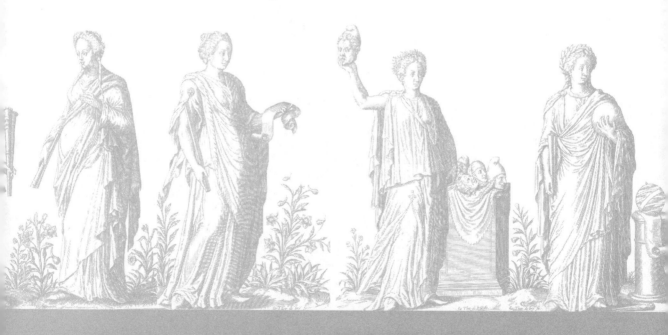

JEREMY P. TARCHER/PUTNAM
a member of Penguin Putnam Inc.
New York

Most Tarcher/Putnam books are available at special quantity discounts for bulk pur-
chases for sales promotions, premiums, fund-raising, and educational needs. Special
books or book excerpts also can be created to fit specific needs. For details, write Put-
nam Special Markets, 375 Hudson Street, New York, NY 10014.

Jeremy P. Tarcher/Putnam
a member of
Penguin Putnam Inc.
375 Hudson Street
New York, NY 10014
www.penguinputnam.com

Library of Congress Cataloging-in-Publication Data
Arrien, Angeles, date.
 The nine muses : a mythological path to creativity /
Angeles Arrien.
 p. cm.
 Includes bibliographical references.
 ISBN 0-87477-999-5
 1. Muses (Greek deities). 2. Creative ability.
 I. Title.
 BL820.M8.A77 2000 00-030226
 292.2'114—dc21

Printed in the United States of America

10 9 8 7 6 5 4 3 2 1

This book is printed on acid-free paper. ♾

Book design by Mauna Eichner

acknowledgments

Throughout this entire project with all its changes, additions, and detailed synthesis, Twainhart Hill stood by me undaunted as any muse would. As creative project manager for this book, Twainhart's commitment, tenacity, loyalty, and generosity provided the exact support needed in manifesting this creative endeavor. Her skill as a project manager for all the art, photos, and permissions created a collaborative environment where the following people could bring forward their input, gifts, and talents as needed during different phases of this book. My heartfelt gratitude and appreciation to each and every one of you who provided computer skills, feedback, research, photos, art, ideas, and help surrounding this book:

Victoria Engel and Pat Rockwell, my office and support staff.

Art and Photographic Resources: Connie King, Rita Wood, Kris Dickinson, Charles Hobson, Linda Pomerantz, Heather Marsh-Rumion at Corbis, and Renee Dreyfus, curator of ancient art, San Francisco Art Museum.

Researchers: Aida Merriweather, Jessalyn Nash, Nahrain Daniel Moran, Amy Pierre, Nancy Feehan, and Michael Chapman.

Computer Expertise: Gunnar Kiene and Christine Krieg.

Collegial Support and Feedback: Patrick O'Neill, Frances Vaughan, and Bernard Lietaer.

Permissions Assistants: Ani Tenzin Lhadron and Anna Yang.

My editors and publishers at Tarcher/Putnam provided excellent support and feedback: Jeremy Tarcher, Joel Fotinos, David Groff, Martha Ramsey, and Claire Vaccaro for her exquisite gifts in design.

My sister Joanne Arrien, whose ideas and suggestions reshaped important parts of this book.

This book is dedicated to my grandmothers . . .

ɟuana osa ɛloɾdi

and

pɛtɾa ʙaɾɾayasaɾa ʌɾɾiɛn.

Thank you for the leaps of faith and long strides of Spirit that you took to

pave a solid and creative road for your Basque children and grandchildren,

so that they could do the same in similar and different worlds.

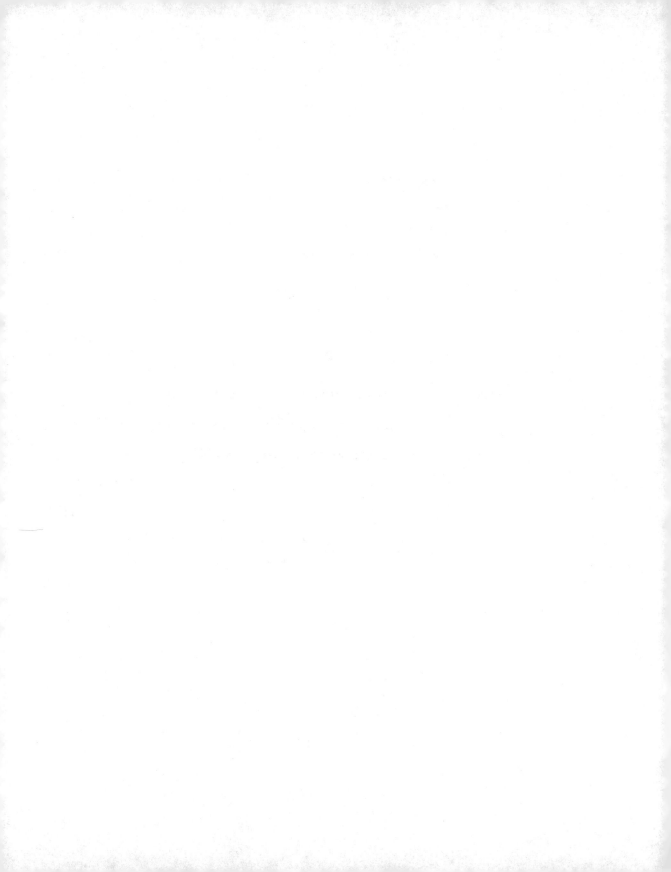

contents

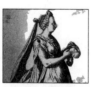

Apollo struck his lyre, and the Muses lifted their sweet voices, calling and answering one another. But when the sun's glorious light had faded, they went home to bed, each in his own abode, which lame Vulcan with his consummate skill had fashioned for them.

HOMER

The *Iliad*

Memory tempers prosperity, mitigates adversity, controls youth, and delights old age.

LACTANTIUS

Poetry is the record of the best and happiest moments of the happiest and best minds.

SHELLEY

clio

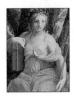

Muse of History and Writing

*Sometimes the
inspiration is history.*
JULIA ALVAREZ

erato

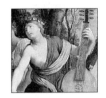

Muse of Love Poetry

*Love is a canvas furnished
by Nature and embroidered
by imagination.*
VOLTAIRE

euterpe

Muse of Music

*Without music, the heart
and the soul cannot find joy.*
ANONYMOUS

melpomene

Muse of Tragedy

*Where there is sorrow,
there is holy ground.*
OSCAR WILDE

polyhymnia

Muse of Oratory, Sacred Hymns, and Poetry

105

*Poetry is sacred songs and
stories from the soul.*
ANONYMOUS

terpsichore

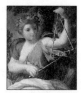

Muse of Dance

117

*There is a vitality, a life force, an
energy, a quickening that is
translated through you into
action, and because there is only
one of you in all of time, this
expression is unique.*
MARTHA GRAHAM

thalia

Muse of Comedy

129

*True humor springs not more
from the head than from the
heart. It is not contempt;
its essence is love—It issues not in
laughter, but in still smiles,
which lie far deeper.*
CARLYLE

urania

Muse of Astronomy and Science

139

*The contemplation of celestial
things will make a man both
speak and think more sublimely
and magnificently when he
comes down to human affairs.*
ANONYMOUS

preface

In the last decade, four creative questions have whispered of a pageant of learning for me. Each question has been unequaled in its private hauntings and insistence to explore the untamed current of creativity present within it. What each one had in common was its relentless drive to find a container to hold its full expression. *The Nine Muses* finally became the place where all four questions merged to create a greater exploration of some possible answers or expanded inquiry.

If you are seeking creative ideas, go out walking. Angels whisper to a man when he goes for a walk.
RAYMOND INMON

The four questions

1. What are the emerging dreams, visions, myths, or new/old stories that will support the evolutionary process and spiritual needs of humanity as we move into the twenty-first century?

2. If we are here to learn about love and creativity, how can we create a world that works for everyone? What would that take?

3. What are the creative tools, images, and myths we can use to dim the ego, befriend the shadow, and build bridges that unify polarity, opposition, and paradox?

4. What is the healthy feminine? What signals its presence? Its absence? What is the healthy feminine's unshakable and essential function in the world? How can we restore and sustain a Way of Beauty in the world?

ANGELES ARRIEN
SAUSALITO, CALIFORNIA

"Invocation"

My muse burns
a holy candle
to the nite
as She lies quiet
in the other room
the space
between us
a mystery
like walking
on air
what I know
fits
in my closed hand
the rest
a vision
and my Muse
guiding me.

FRANK T. RIOS

Derivation of the word MUSE

As synthesized by Michael A. Chapman

The noun "MUSE" is not only an English word but is found also in Old French. In Latin, the word is MUSA, and in Greek MOUSA, perhaps for MONTHIA, from MANTHANEIN, meaning TO LEARN. The Indo-European base is perhaps MENDH-, meaning TO DIRECT ONE'S MIND TOWARD SOMETHING. From the Greek MOUSA, plural MOUSAI, we have the derivative MOUSEION. A MOUSEION was a PLACE OF STUDY or LIBRARY, a SEAT, SHRINE, or TEMPLE of the Muses, called a MUSEUM in Latin and adopted by English. From the Greek MOUSEION we also derive the words MOSAIC, and MOUSEIKE or MUSIC, lyric poetry set to music.

The verb MUSE comes from Old French MUSER, meaning TO LOITER, TO PONDER, TO REFLECT, probably originally TO STAY WITH ONE'S NOSE OR MUZZLE IN THE AIR, from Old French MUS, attested by Old French–French MUSEAU (Italian: MUSO), Middle Latin MUSUM, variation MUSUS, meaning MUZZLE, and animal's MOUTH or SNOUT. The Old French–French word MUSER has the compound AMUSER, meaning TO CAUSE TO STAND WITH MUZZLE IN AIR, hence to BEMUSE.

The sound and the letters of MU or MOU, the basis for the word MUSE, relates to the CREATIVE MUCK or MU-CUS, for out of the SLIME and PRIMORDIAL WATERS or SOUP (with the O, U, and S of MOUS) came or arose the SOUNDS AND FORMS of all CREATION. From the MOUNDS or MOUNTAINS, from the Mother Earth herself, came the FLOWS and SWIRLING EDDIES OF LIFE ITSELF BORN ANEW. The waters and the earth are the FEMININE elements of the physical world, the sources of FLOWING RIVERS and LAVA STREAMS spewing forth from deep inside the planet.

Finally, in terms of the etymological trail of the word MUSE, look at the word MYSTERY. A MYSTERYE was a SECRET or HIDDEN thing, borrowed from the Latin MYSTERIUM, from Greek MYSTERION, meaning SECRET RITE or DOCTRINE, the Divine Secret, from MYSTES, meaning ONE WHO HAS BEEN INITIATED, from MYEIN or MUEIN to SHUT THE EYES. About 1390, the word MYSTERYE meant MINISTRY or SERVICE. Later,

a MYSTRIE was an ART or HANDICRAFT. The Greek MYTHOS means SPEECH, THOUGHT, STORY, LORE, obviously related to the gifts of the Nine Muses.

The Latin MYSTERIUM is merely a transliteration of the Greek MUS-TERION, itself akin to the Greek MUSTES, literally meaning CLOSED-MOUTHED, hence, as a noun, an initiate into a religious mystery: MU, a GROAN (related to MUTE) and the suffix ISTES. Contributing to MUSTES is MUO, meaning I SHUT MY MOUTH AND CLOSE MY EYES. The Greek word MUSTES has the derivative adjective MUSTIKOS, Latin MYSTICUS, and Middle French MISTIQUE that became the English word MYSTIC.

muse
from the Greek verb *muein*—
to initiate somebody into
the mysteries.

introduction

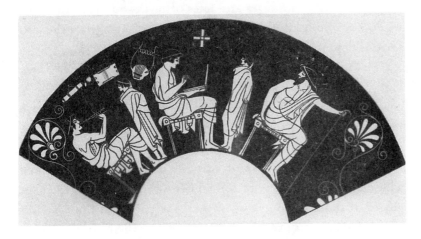

Music was an essential part of Greek education. Their musical practice centered around the lyre, the root of lyricism; and the wind instrument the aulos, associated with dances.

Paul Henry Lang
A Pictorial History of Music

The purpose of Myth:
A Bridge from Humanity to the Mystery

Myth takes us deep into ourselves and into the mysterious reservoirs of humanity. In *Tracking the Gods: The Place of Myth in Modern Life,* James Hollis reminds us that whatever our cultural and religious background or personal psychology, a greater intimacy with myth provides a vital linkage with meaning. Hollis aptly explains how the absence of this meaning is so often behind the private and collective suffering of our time.

Myths are archetypal patterns in human consciousness.
JOSEPH CAMPBELL

Expressed in its most succinct form, the study of myth is *the search for that which connects us most deeply with our own nature and our place in the world.* This human search for, and experience of, what connects us to a deeper intimacy and understanding of ourselves and our contribution in the world is a central issue we confront both collectively and individually.

The Greek word *mythos* means word, story, speech, related to the notion of expression or that which carries meaning. Myth,

1

with its relationship to symbol, metaphor, and meaning, bridges the unknown to the known and helps us exist in a meaningful relationship to the sacred mystery of who we are and why we are here. By definition we cannot fully know these mysteries, but we are driven by internal biddings to stand in significant connection to them. The images and tales of myth touch us even when we do not wholly know why, simply because they activate the mysterious depths we embody.

Myth resonates within us because it gives shape to what we already carry in our nature, even though we can only dimly perceive or understand it. Hollis clearly describes the function of myth when he says that myth draws us near the images that explore the profound depths of love and hate, creativity and inertia, life and death, joy and sorrow, the sacred and profane. These are the precincts of the gods, the mysteries, where categories of thought falter and slip into silence and the imagination. Myth is a way of talking about the ineffable and begins to reveal the coded language of the soul.

The psychological task of myth is to help us understand more fully who we are. Literally, this means moving us to ask questions such as: Who am I? How am I to conduct my life? Where am I going? What is my proper place in the world? How can I best serve this world? What is my vocation, life purpose, or calling?

Asking these questions, which speak to broad concerns of identity, we begin to tap into our own personal myths that evolve and change as we grow. In their book *The Mythic Path*, David Feinstein and Stanley Krippner build on this concept that our personal myths become a lens that gives meaning to every situation we meet and determines what we will do with it. These personal myths explain for us the external world, guide personal development, provide social direction, and address spiritual questions in a manner that is analogous to the way cultural myths carry out functions for entire groups of people.

Myths within cultures support the individual in attaining a sense of self, as well as guiding social interaction and cultural

development. According to the widely esteemed mythologist Joseph Campbell, the traditional domains and questions of cultural mythology include asking: How do we culturally comprehend the natural world in a meaningful way? How do we collectively search for a marked pathway through epochs of human life? How do we establish secure and fulfilling relationships with a community? How do we know our part in the vast wonder and mystery of the universe? A measure of our personal and collective development will hinge on two factors: our willingness to accept responsibility for finding our own myths of love and creativity, and our ability to hold the ambiguity and creative tension that always precedes the emergence of something dormant or new. These twin processes—to live one's own life and to serve the mystery—are critical for the health of both individuals and society.

Paradoxically, these are aspects of the same thing. Each process requires not only a willingness to accept responsibility for the course of one's life and for the meaning it embodies but also the conviction of one's right to make a contribution and to experience the unique path it may take, distinct from that of those who have gone before. To reach the end of one's life and to know that one has not truly taken the journey or made a contribution is more terrible than any terrors one would have had to face on the way. This is the ultimate personal and collective betrayal that philosopher Elie Weisel reminds us of when he says, "If we do not transmit our experience, we betray it." How can we transmit our experience in creative, responsible ways? What are the current soul images that focus our attention and ignite the transmission of our experience so we can explore our personal and collective myths?

The poet Rainer Maria Rilke also suggests our possible work in his poem "Turning Point":

> Work of the eyes is done, now
> go and do heart work
> on all the images imprisoned

within you; for you
overpowered them . . . Learn . . .
the not yet beloved form.

What is the heart work to be done? What are the soul images imprisoned within us? Which ones have we overpowered or neglected? Which images have meaning or are beloved but not yet explored? How can we express them and learn from them? The Greek word for Soul is *psyche*—that part of our nature that expresses itself through image but is not that image. When the image or symbol no longer points beyond itself to the precincts of mystery, then it is dead. As with personal myths, Hollis says, a culture whose mythologies are too fragmented creates frightened and lost people who drift from cult to cult, ideology to ideology. This phenomenon, or activity, signals the need for the creation of new myths or the need to surface dormant ancient ones for personal and collective development.

At different times in history, certain archetypal collective images tend to emerge and recede again—in response not only to evolutionary processes but also to the spiritual needs of humankind. According to psychologist Carl Jung, there exists in the collective unconscious a clear tendency to understand dualities and paradoxes—especially the poles of good and evil, which have split too far apart in our time. Jung felt that the needed reconciliation could only come through an intermediary, which he believed to be the neglected feminine principle found in both men and woman.

Perhaps the emergent images that can most assist us in claiming the neglected feminine principle are the Muses. In Greek mythology, all nine Muses are divine forces in the form of women that guide us in the making and remaking of the human spirit and the world. Each one calls us to a path of creativity and a commitment to live an authentic life. William Butler Yeats describes the Muses' mandate in a terse phrase: "To speak of one's emotions without fear or moral ambition, to come out from un-

der the shadow of the men's minds, to forget their needs, to be utterly oneself, that is all the Muses care for."

Relentlessly the Muses call forward our authenticity and our gifts and talents. All nine of these mythical creatures inspire us to create our futures and to meet our destinies; compel us to take up our own soul tasks; and require us to bring our authentic natures to Earth—which are all functions of the feminine principle found within each man and woman. What the Muses tell us is that the beauty of the human spirit is not an external decoration or a frivolous expensive adjunct to serious matters like knowledge, work, justice, or social responsibility. Rather our inherent beauty lies in trusting our deepest natures and authentically expressing who we are in the world in wise and life-affirming ways.

the muses:
creative messengers from the mystery

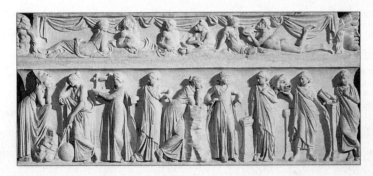

Who are the Nine Muses and how can they be important mythical images at this time in history? The daughters of Mnemosyne and Zeus, the Muses are the issue of Divine Love. Mnemosyne, whose name means "memory," gives remembrance of our easily forgotten connection to the Divine. Zeus, the Awakener and Maker god with thunderbolts and lightning as his tools, forges ways to bring heaven to Earth. His nine daughters became the custodians of inspiration and the creative fire—bringers and ig-

The Muses would speak with Shakespeare's fine filled phrase if they could speak English.
FRANCIS MERES
Palladis Tamia: Wits Treasury (1598)

niters of the arts and sciences within the human spirit. Often referred to as "sacred epiphanies," the Muses ignite our creativity and educate our soul.

The Muses inspire us to hold creative forms or images that guide us in making music, dancing, speaking, writing, inventing, grieving, worshiping, playing, singing, and loving. All of these forms are needed as ways of relating with each other; of being "in community"; of having "presence," or being whole within ourselves.

In our present age, the Muses call us to live our lives with integrity and devotion to their chorus of inspiration, which may entail "being in the world but not of it." They invite us to adorn our lives with creativity and beauty while living in a culture that sees beauty as "purely subjective" and otherwise irrelevant. In a world where taste and aesthetics are anaesthetized in exchange for efficiency and mass production, they encourage us to develop our aesthetic sense and to increase our sense of beauty and creativity. Above all, the symbol of the Muses invites us to be resourceful in daily life. They initiate us to the mystery of who we are and are models of the healthy feminine. The Muses will provide unceasing inspiration to any soul who sincerely evokes their integrity and creativity, for in their eyes a life well lived is a work of art.

The Muses' names are given to us by Greek mythology. Many cultures have their equivalents, although the Greek forms are the most widely known. Some modern or historical examples are added in the parentheses to ignite other examples that may occur to you.

- Calliope: Muse of heroic and epic poetry, storytelling, and eloquence of speech (Walt Whitman, Toni Morrison, Hans Christian Andersen)

- Clio: Muse of history and writing, and giver of fame (Kenneth Clark, Judith Thurman, Doris Kearns Goodwin)

- Erato: Muse of eros, desire, and love poetry (Shakespeare, Marilyn Monroe, Mother Teresa)

- Euterpe: Muse of music and bringer of joy (the Beatles, Ella Fitzgerald, Mozart)

- Terpsichore: Muse of dance and movement (Isadora Duncan, Merce Cunningham, Martha Graham)

- Thalia: Muse of comedy, play, and celebration (Lucille Ball, Bob Hope, Mary Tyler Moore)

- Polyhymnia: Muse of sacred hymns, poetry, and oration (Nelson Mandela, Eleanor Roosevelt, Jessye Norman)

- Melpomene: Muse of tragedy who opens the heart through grieving (Diana, Princess of Wales, Columbine High School, John F. Kennedy, Sr.)

- Urania: Muse of astronomy and science (Carl Sagan, Albert Einstein, Marie and Pierre Curie)

These nine Muses appear in our lives in both direct and subtle ways. When the number "nine" comes up in our speech, the Muses announce their presence: "a cat has nine lives; dressed to the nines; go the whole nine yards; to be on cloud nine; a stitch in time saves nine." All are ways of reminding us that the Muses are there to assist us in bringing our gifts and talents forward to the world and to become more whole. In a more subtle way, they live within and through us. Mathematician and scientist Michael Schneider continues to reveal the importance of the number nine in science, culture, and mathematics by reminding us that there are nine openings in the body; it takes nine months to be born; and nine rings comprise the centriole of the human cell. Cultural uses of nine are found in China, with nine-story pagodas; Native American, Aztec, and Mayan myths speak of nine cosmic levels; and in Christian symbolism we find nine orders of angelic choirs in nine circles of heaven, and nine orders of

devils within nine rings of hell. The Greek poet Hesiod, in his *Theogony*, describes the Muses as "all of one mind" and describes how their nine voices tend to unite into one creative song:

> *There are their bright dancing places and beautiful homes, and beside them the Graces and Desire live in delight.*
>
> *And they, uttering through their lips a lovely voice, sing the Laws of all and the Godly ways of the immortals, uttering their lovely voice.*

When there is excellence, beauty, inspiration, and extraordinary creativity in the world, we know that the Muses are present within men and women to celebrate and ignite within us the unlimited beauty and creativity available within the human spirit.

The Muses in contemporary Life

The pervasive presence of the Muses in our contemporary lives is best expressed by Julia Alvarez, in her book *Something to Declare*, when she writes:

> Of course, there were other voices in my head, other instincts. Along the way, I met other muses whom I made the mistake of ignoring because I had never seen their faces between the covers of the books. They did not seem important enough, American enough, literary enough. In silencing them, I was silencing myself. I found my voice only when I let them sing inside my work, when I sat down and finally listened to them.
>
> I am not talking now about book muses—fairy tale heroines like Scheherazade or heroines in novels like Jo in *Little Women* or even writer heroines whom I fell in love with at different times in my reading life. Certain soulful passages of my George Eliot novels are marked so heavily, that

I am embarrassed to lend them out. . . . And as for poetry, I have touched certain volumes to my cheek as if they were favorite aunts who had given me a special gift.

But I'm talking now about real-life muses—ones who never wrote a book but who stirred my imagination with their pluck and sometimes with their failures; whose cheeks I really touched; who held me and told me I could do it, which is a muse's primary job. I don't know if these are the same muses Milton and Homer meant when they invoked The Muse, but now that I am an older, chastened, and somewhat humbler writer, I know the muse is many muses, and not all of them leave paper trails.

The real-life muses that show up in our lives are often found in our relationships, especially in those where each partner or important friend encourages each other's creative achievements and where each fosters mutual support for the emotional and intellectual well-being of the other. Artist and writer Charles Hobson in his book *Parisian Encounters: Great Loves and Grand Passions* says that the muse relationships he describes had certain common attributes. Each person was an important partner in the other's career and drew something essential and critical from the encounter. No matter how long the liaison lasted, the impact of each on the other's life was momentous. Often the details of their first meeting are quite ordinary—a spark of recognition left each partner a little surprised. Ultimately that surprise turned into a deep connection fueled by the respect for the other's talent and capability. These kinds of liaisons remind us that we are all, in part, a patchwork of the people we have met and the experiences we have encountered.

"Upon the Intimation of Love's Mortality"

It is the effort of the lie
Exacts a wounding pulse.
I loved you much

When everything had excellence at once.
First was our freshness and the stun of that.
Your body raved with music. What was lost
Is just that element our time always takes
And always in love we venture off some height
That nothing else can equal after it.
The thought of that bedevils me for miles.
How can I save you from my own despair
To think I may not love you as before?
Spoiled, we become accustomed to our luck.
This is the devil of the heart.
We were the smiles of gods awhile
And now, it seems, our ghosts must eat us up
Or wail in temples till our tombs are bought.
Attended now by shades of that great while,
Disguise is the nature of my guile
And yet the lie benumbs the soul.
Get me the purity of first sight!
Or strength to bear the truth of after light!

JEAN GARRIGUE

Muses for Each Other: Creative Collaborators and Passionate People

- Mark Antony and Cleopatra

- Peter Paul Rubens and Hélène Fourment

- Anaïs Nin and Henry Miller

- Federico Fellini and Giulietta Masina

- Jasper Johns and Leo Castelli

- Diego Rivera and Frida Kahlo

- Johannes Brahms and Clara Schumann

- Marie Curie and Pierre Curie

- Charles Lindbergh and Anne Morrow Lindbergh

- Martha Graham and Louis Horst

- Emily Brontë and Charlotte Brontë

- George Burns and Gracie Allen

- René Magritte and Georgette Magritte

- Margot Fonteyn and Rudolph Nureyev

- Auguste Rodin and Camille Claudel

- Robert Browning and Elizabeth Barrett Browning

Louise Colet and Gustave Flaubert.

Gustave Flaubert met Louise Colet in the summer of 1846 as she posed in the studio of the sculptor James Pradier. Louise, then thirty-six, was eleven years older than Flaubert. She was an established poet within Parisian literary society—and beautiful. He was unknown and unpublished . . . an affair flared and then smoldered for eight years as Flaubert conceived and executed his novel *Madame Bovary*.

CHARLES HOBSON
Parisian Encounters: Great Loves and Grand Passions

The Emergence of the feminine principle in the Twenty-first century for Men and women

The new meaning of soul is creativity and mysticism. These will become the foundation of the new psychological type and with him or her will come the new civilization.

OTTO RANK

Who are the people in our lives who have been Muses for us? For whom are we a Muse? Both men and women serve as creative and spiritual catalysts for each other—as do men for men, and women for women. When this ignition takes place in our lives, these catalytic people serve as mirrors of deeper internal and creative processes within ourselves that want to be released and fully expressed, whether we are conscious of it or not. The value of tracking the people, places, or things that inspire, surprise, challenge, or touch us reveals to us the presence of a Muse and the feminine principle that is working within each man and woman.

The feminine principle is the part of our nature that trusts the intuitive and emotionally honest aspects of ourselves. One of the essential qualities of the feminine psyche within each man and woman is its capacity for devotion. Jungian psychologist Robert Johnson reminds us that the great offering of devotion is to give of that which is most loved to the god who is yet unknown. The shadow side of this would be blind devotion. Men and women make this great offering when each is willing to risk the loss of a relationship rather than make possessive demands on the person loved; and when they are willing to sacrifice their achievements in the world rather than betray their deeper values. To both men and women these great offerings bring the experience of Eros, the god of love, or a deeper engagement with one of the Muses. The future rests upon this quest in order for the heart of love and creativity to be more fully expressed by both sexes.

When a woman feels the immense fascination of the creative power of spirit stirring within her, how is she to welcome these internal promptings and remain true to her womanhood; or

how is she to rediscover her femininity if she has lost it? How is
a man to recognize the values of the creative heart without losing
the clarity of his spirit in an ocean of emotion? Disturbing be-
haviors emerge within both sexes that signal or announce the
longing to develop more Muse-like creativity and connect with
the healthy feminine. These shadow behaviors are announced by
patterns of drama, seduction, appeasement, control, aggres-
sion, withdrawal, pride, resentment, martyrdom, isolation, and
extreme anxiety or numbness. Alan Chinen in his book *The Wak-
ing World* reminds us that both sexes are required in their creative
journey to be vigilant to the four distinct tasks that mark the de-
velopment of the healthy feminine principle. Practicing these
tasks and incorporating them into our lives will ease the behav-
iors of discomfort and release the creativity wanting to be ex-
pressed:

1. Defying the demon: cultivating the ability to identify,
 confront, tame, outwit, befriend, or overthrow both
 cultural and internal demons.

2. Reclaiming the true self: developing the ability to move
 out of insufficiency and hiding to trust and have faith;
 and take a rightful place in the world while finding
 comfort, refuge, healing, and inspiration in silence and
 in the wilderness.

3. Befriending the feminine in others: commiting to the
 spirit of collaboration and cooperation; and celebrat-
 ing the sacrament of beauty and authenticity found
 within oneself and others.

4. Awakening the world: breaking through secrecy, illu-
 sions, and constricting customs in order to model
 strength, wisdom, and self-responsibility. To awaken
 the world is to fully realize that initiating social changes
 goes hand in hand with the transformation of intimate
 relationships so that development can occur in both in-
 ner and outer worlds.

The ultimate call of the Muses in contemporary life is to live a creative and authentic life. The feminine principle, as reflected by the Muses, is a commitment to the renaissance of creativity, spontaneity, and authenticity. The Muses are essential stewards and initiators of the creative healthy feminine principle—that which beautifies, contains, nurtures, deepens, and remains still and that which responds to people and things without any will to use or manipulate them. The healthy feminine principle provides a safeguard in silence to secure and nurture the mystery of life and the mystery of creativity. If women and men do not themselves take up the authentic quest of the "Grail," it is certain that the equality that is gained in ruthless and strategic ways will lose its meaning and become another "wasteland," as T. S. Eliot called it. A great hope for the future lies in the fact that so many people have the creative opportunity to enter this quest with genuine intention and sincere motivation to collaborate in creative endeavors that will support and contribute to the common good of all concerned. This is the creative enterprise of the feminine principle in all human beings.

Apollo and the Muses.

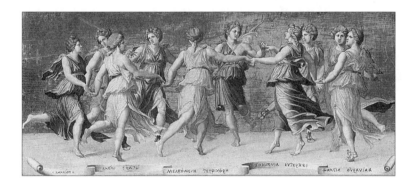

How to work with the Muses in this book

The following chapters introduce each of the Muses and their domain of creativity and inspiration. Each Muse has her own discipline, yet each discipline is capable of suggesting the range

of all the disciplines taken together. Each of the Muses represents a path to creativity and has her own distinct role or function in leading us further into our creative lives and true artistry, regardless of our cultural conditioning or family imprinting.

The Nine Muses show themselves to us in all moments of inspiration—a sudden flash of finding the solution to a problem, a state of grace, a brilliant thought about a future project, a witty remark; or experiencing original thoughts accompanied by high euphoria or agitation. In the presence of a Muse, we forget about tiredness as inspired spontaneity puts an end to doubt or tension. The Muses, as the awakened feminine principle within us, take us either to where the earthly and the divine meet or where creativity stretches us to simply go beyond our knowledge and experience. Their domain lies in matters of the heart and in every creative endeavor that fires the soul.

Our opportunity is not only to recognize and open to their presence and visitation, but also to develop the capacity of holding them within our imagination. The following chapters are designed to help you access the inspiration of each Muse by creating your own invocation for each one and by working with the questions and material at the end of each chapter to discover how each Muse invokes your own creativity in your life. The activities and reflections are there also to spark your own explorations and creative ideas. To further the learning, each chapter contains multiple ways of igniting memories and the imagination through visuals, poetry, information, quotes, art, reflections, and questions to open the doorways of creativity and spirituality represented by each Muse. The chapters are to stimulate the creation of your own Muse Journal for capturing what each Muse triggers within you or ignites in the way of your own creativity and private literature. By inviting their presence into our lives to help us unleash our creative gifts and talents in life-affirming ways, we become a bridge for their entry and manifestation into the world.

The Muses remind us of our individual work and collective myth—that in order to love each other and create a world that

enhances the common good, we must, as Abraham Lincoln said, attend to the "mystic chords of memory and trust the better angels in our natures." Discover which of the Muses have stirred your musings, amused you, and taken you to those treasured places called museums. Which do you know the best, and which do you know the least? Which ones have been catalytic in your relationships? Who are the people in your life who have been muses for you?

You might work with each Muse for a week, month, or weekend. Or you might want to create a study group of friends and explore each Muse for a month and share your learnings. Each of the chapters are designed to make you feel like you've stepped into a writer's journal or a private creative place to spark your own creative relationship to each Muse. The modern examples in this book of the Muses and the ways they show up in contemporary life are only there to stimulate others you may consider equally or more worthy to be in your own Muse Journal or on your own bulletin board. The historical statues, copper engravings, and paintings of the Muses collected in this book illustrate how the Muses have been represented in art throughout time. They are only a limited sampling of the pervasive presence of these creative forces and their expressions in our lives.

The Muses within and without us are necessary to our individual development and collective survival and the healthy expression of the creative feminine principle. The Muses primarily function as a symbol of the mystery of creativity that allows us to explore our own creative paths and personal destinies. Poet Pablo Neruda described our creative endeavors and muselike explorations this way:

> All paths lead to the same goal: to convey to others what we are. And we must pass through solitude and difficulty, isolation and silence, in order to reach forth to the enchanted place where we can dance our clumsy dance and sing our sorrowful song—but in this dance or in this song there are

fulfilled the most ancient rites of our conscience in the awareness of being human and of being in a common destiny.

Discover which Muse or Muses have taken you to the enchanted place where you have increased your awareness of who you are and have met more fully your own personal and common destiny.

I believe that the moment I open to the gifts of the Muse, I open myself to the Creation. And become one with the Mother of Life Itself.

JAN PHILLIPS

Mnemosyne

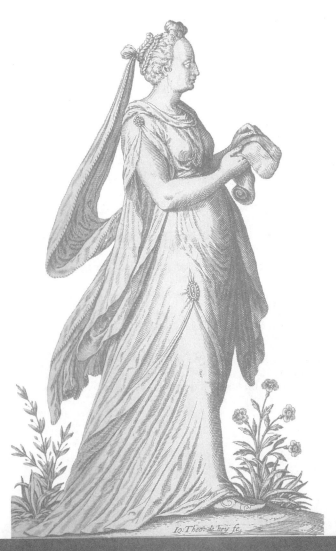

Io:Theo:de hry fe.

Mother of the Muses
The Goddess of Memory

I would have you imagine, then, that there exists in the mind of man a block of wax, which is of different sizes in different men; harder, moister, and having more or less of purity in one than another, and in some of an intermediate quality. . . . Let us say that this tablet is a gift of Memory, the mother of Muses; and that when we wish to remember anything we have seen, or heard, or thought in our own minds, we hold the wax to the perceptions and thoughts, and in that material receive the impression of them as from the seal of a ring; and that we remember and know what is imprinted as long as the image lasts; but when the image is effaced, or cannot be taken, then we forget and do not know.

PLATO

The Titan goddess Mnemosyne ("of memory") was the daughter of Uranus, the sky god, and Gaia, the earth goddess. Mnemosyne was given her father's and mother's gifts in equal proportion. From her father, Uranus, she received imagination, innovation, and originality. From her mother, she valued the gifts of memory, recollection, and creativity. Her memory and imagination skills were acute, and the Olympian gods and goddesses were aware of her formidable gifts. After the Olympians defeated their Titan rivals, who were known as superb creative deities, the gods asked Zeus to create divinities who were exceptionally innovative and capable of infusing mortals and immortals with abundant gifts and talents.

Zeus knew that if he coupled with one of the Titan goddesses, the gigantic goddesses of creation, that the mergence of an Olympian god with such a goddess would ensure the survival of inspired creativity and would give birth to creative forces that could last through all time. He sought out the most gifted of the Titan goddesses, Mnemosyne, who lived in Pieria. Once he found and charmed her, he shared Mnemosyne's couch for nine consecutive nights. When her time had come, Mnemosyne gave birth to her daughters, who became the nine creative divinities known as the Muses.

Mnemosyne made sure that her daughters' inherent beauty, gifts, and talents were well developed, for she knew they would ignite the forces of creativity whenever they were present. Although she allowed her daughters to visit Olympus often, she made sure that they continued to locate their home in nature on Helicon, a high mountain in Boeotia. In this environment, her daughters renewed and cultivated their unlimited creative gifts near the numerous streams, geysers, and fountains that gushed forth under the hoof of their favorite winged horse, Pegasus. Pegasus, according to Homer, comes from the word *pegae* in Greek, which means "geyser." When Pegasus's hoof hits the ground, a geyser springs forth, and instantaneously, the Muses appear and gather around the well. Many said that those who drank from

Every man's memory is his private literature.
ALDOUS HUXLEY

these waters would be endowed with gifts of poetic inspiration, prophetic insight, heightened creativity, intellectual curiosity, and song.

In this environment, Mnemosyne trained the voices of her daughters to carry the rhythm and sounds of divinity and memory. She taught them about timelessness through repetition, rhyme, rhythm, sound variations, images, and varied forms of seeing and creativity. She instilled the art of musing into each of her daughters, so that each knew the benefits of reflection and recollection. For her daughters, Mnemosyne made sure that learning was an amusing adventure and exploration. She taught them about the delights of discovery, play, silence, reverie, and dreaming. As a mother, she taught them about all aspects of culture and creativity that left legacies of beauty and well-being. She reminded them that the seat of memory was in both the heart and the brain; and that to learn by rote, or to memorize, something meaningful was "to know it by heart." To ensure that her daughters would not forget all that was imparted to them, Mnemosyne developed within them two memories and imaginations. She made sure that each was highly developed in each of the following (both of which Ginette Paris describes further in her book *Pagan Grace: Dionysos, Hermes, and Goddess Memory in Daily Life*):

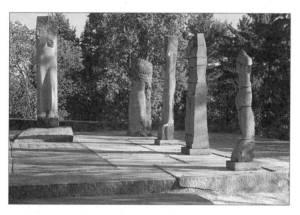

Carlos Dorrien worked on his Nine Muses project for seven years.

- The memory and imagination of the collective past held in oral cultures and traditions who believed that if values and traditions were committed to memory they could never be lost and could be passed on for generations

- The memory and imagination of the present and future found in literate (and now computerized) societies, as well as highly developed speaking traditions

BRINGING MNEMOSYNE INTO YOUR LIFE
MOTHER OF THE MUSES

Write your own invocation to bring
Mnemosyne into your life:

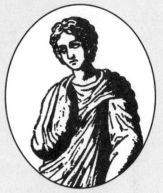

Invocation

O Mnemosyne, witness to all acts of
creation, preservation, and
destruction,
Mother of the Muses,
Reverence to you for your vast
storehouse of memory
and perennial wisdom!
Initiate me into the wisdom of
Memory
and vision of Imagination.
Let me draw upon your rich
memory and experience to
create in the present what
is needed for the future.
Guide me to remember what
is important to my Soul's purpose.
May I trust what I know by heart.

Mnemosyne's legacy to the Muses was to value the impor-
tance of perpetuating these two memories and imaginations—for
the two cocreate a timeless and inextinguishable flame of creativ-
ity housed within the human spirit.

Mnemosyne used mnemonic devices and the structures of
narrative, epic, dance, song, history, hymns, comedy, tragedy,
and images to preserve remembrance and foresight of all things
natural, divine, and healthy within her daughters. The Nine
Muses are the creative divinities who ignite the human spirit to
explore and express the arts and sciences, and to discover the
presence of divinity in its own musings, amusements, music, and
museums. The Titan goddess Mnemosyne, the mother of the
Muses, can be put to sleep, but she is never forgotten, and she
never dies—such is the infinite work of memory, imagination,
and the healthy feminine.

"memory"

TENNESSEE WILLIAMS

Life is all memory, except for the one present moment that
goes by so quick you hardly catch it going.

SUSAN MITCHELL

Why did I suddenly think of this today? Why remember
something I have not thought of in years? Now that I have
remembered, I am obsessed with it, especially with that
sound of the flame flaring up. There's a glaze over the
memory, the kind of glaze that Van Eyck used. Even the ob-
scure, smoky places in the memory, even what I don't see
clearly is highly glazed and shines as if a candle were held to
it. Even that sound, that flap of air, breath catching shines.

GARRETT HONGO

The trick is to make the memory, (or) the imagined expe-
rience, stronger than anything else in one's consciousness,
to make the "pretend game" the one that counts, that is the
death trap. Tricks of the mystics and the contemplatives
should prove handy: simplify one's life; spend lots of time
in solitude; avoid chaotic, undisciplined experiences until
one is prepared to encounter them; quell the violent pas-
sions (jealousy, envy, malice). I'd add one dictum probably
not present in any handbook for contemplatives—cultivate
a refined sensuousness. Lots of the great and the near-
great did this—one has only to think of Monet's gardens at
Giverny, Neruda's study full of varicolored, beach-scav-
enged bottles, ships-in-bottles, conch shells, and that sea-
siren Madonna he scrounged and subsequently enshrined
near his desk. Wordsworth had the entire Wye Valley, Frost
his New Hampshire farm, Jeffers Tor House, Yeats his
tower in Coole Park or Ballylee.

T. S. ELIOT

> . . . *we die to each other daily.*
> *What we know of other people*
> *Is only our memory of the moments*
> *During which we knew them. And they have*
> *changed since then.*
> *To pretend that they and we are the same*
> *Is a useful and convenient social convention*
> *Which must sometimes be broken. We must*
> *also remember*
> *That at every meeting we are meeting a*
> *stranger.*
> "THE COCKTAIL PARTY"

Bringing Mnemosyne into Your Life

Make a Muse Collage or Bulletin Board for Memory

It is something I aspire to in my poems—to make a place—a landscape of psychological and spiritual texture. Not a narrative, but a place made of words.

LAURIE SHECK
The Poet's Notebook

The Goddess of Memory

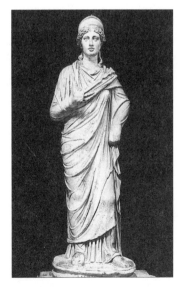

Mnemosyne. The goddess of memory reflects on what is important.

REFLECTIONS:

For the Greeks, memory was "the waker of longing."
J. D. MCCLATCHY

1. Create a quiet reflective space where your Muse of Memory, "the waker of longing," can find you. As you work through each chapter, also create a space for each Muse. Create a special Muse Journal or binder with sections for each Muse or create a computer file to keep your findings as you work with each chapter. Create a

bulletin board or an unusual wall space where you can add or gather photos, quotes, ideas, poems, places, or people that inspire you or remind you of each Muse as you work with her.

2. List three important memories you cherish from your life, or three important "longings" you currently have.

Create a place in your journal for "musings" or reflective questions such as these:

- What would your "personal literature" be?

- What inspires, challenges, surprises, and touches you about each of these memories or longings?

- What creativity was released or sparked as a result of these three memorable situations or longings?

- What major changes came out of these three memories? In your work, in your relationships, or in yourself? What do you hope your current longings will catalyze in your life?

Memory feeds imagination.
AMY TAN

3. Collect memories from family members. Take advantage of a special evening, such as Thanksgiving or Christmas. Shared memories and history can create intimacy, can spark creative expression, and can become part of your personal literature.

Explore and trace your family genealogy and history. Some important tracking resources are:

- The Family History Library of the Church of Jesus Christ of Latter Day Saints, 35 North West Temple Street, Salt Lake City, UT 84150; 801-240-2331

- www.familysearch.org

- www.cyndislist.com

The longing to tell one's story and the process of telling is symbolically a gesture of longing to recover the past in such a way that one experiences both a sense of reunion and a sense of release.
BELL HOOKS

Close-up of a ceramic substrate wires. Such wires might be used to connect logic and memory chips in computers—a graphic example of Mnemosyne's presence in our lives today.

MODERN
MNEMOSYNE

At the U.S. Memoriad '99 in New York City, Tatiana Cooley won for the second time the U.S. Memoriad contest and is a world-class mental gymnast for memory recall. She paired seventy names and faces after studying a stack of one hundred portraits for just twenty minutes.

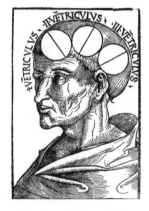

Woodcut of the human brain
with three memory cavities.

Dr. Antonio Damasio at the University of Iowa's department of neurology is America's most noted authority on tracking how memories are recorded and sorted to be retrieved in many locations of the brain.

4. Mnemonic devices are named after Mnemosyne and are memory aids. What mnemonic devices do you use for memory recall? One of the most popular mnemonic devices for remembering the Great Lakes is H-O-M-E-S: H for Huron, O for Ontario, M for Michigan, E for Erie, S for Superior. You could memorize the Muses' names by using the following pattern or make one up yourself: (E.T.C., E.T.C.—U.M.P.!)

E uterpe

T halia

C alliope

E rato

T erpsichore

C lio

U rania

M elpomene

P olyhymnia

5. We can also enhance memory through journaling, diaries, storytelling, memoir writing, putting our memorabilia together into scrapbooks or photo albums, and interviews and research.

 Write or collect what you know or have heard about your ancestors, other than parents and grandparents.

Create a collage or photo album of significant people, places, and events that you do not want to forget.

6. Take a few moments to reflect on all the things you have committed to memory that you still use: for example, quotes, prayers, stories, information, songs, jokes, or knowledge.

Here are some questions or reflections for your musings section of your journal—or add your own:

- What are the particular themes that you have committed to memory?

- Why are these meaningful or significant to you?

- How do you currently use what you have committed to memory?

7. What other creative ideas, projects, or memories did you have as you worked through these pages? What else would you like to add to your Muse Journal that would honor your own private literature?

Visit "Rediscovering Our Muses" on the Internet: www.geocities.com/~webwinds/thalassa/muses1.htm

Somerset Maugham once advised every writer to keep a notebook—I've taken Maugham's advice to heart. I've kept notebooks called NAMES, IDEAS FOR STORIES, and GOOD LINES OVERHEARD, and indeed, they have helped me pay attention to memorable names, stories, and good lines. But the POETRY notebook while it hasn't helped my powers of observation for a hoot, has been for the last forty years a place to vent steam in private, a seedbed for critical articles, and a parking lot for notions to retain.

X. J. KENNEDY

i am accused of tending
 to the past,
as if i made it,
as if i sculpted it
with my own hands. i
 did not.
this past was waiting
 for me
when i came,
a monstrous unnamed
 baby,
and i with my mother's
 itch
took it to breast
and named it
History.
she is more human now,
learning language
 everyday,
remembering faces,
 names and dates.
when she is strong
 enough to travel
on her own, beware, she
 will.

LUCILLE CLIFTON

"REMEMBER"

Remember the sky that you were born under,
know each of the star's stories.
Remember the moon, know who she is. I met her
in a bar once in Iowa City.

*We cannot escape memory, but
carry it in us like a huge organ
with lungs sucking air for
survival. It is an organ like the
skin, covering everything,
but from the inside.*

JOY HARJO

*Remember the sun's birth at dawn, that is the
strongest point of time. Remember sundown
and the giving away to night.
Remember your birth, how your mother struggled
to give you form and breath. You are evidence of
her life, and her mother's, and hers.
Remember your father. He is your life, also.
Remember the earth whose skin you are:
red earth, black earth, yellow earth, white earth
brown earth, we are earth.
Remember the plants, trees, animal life who all have their
tribes, their families, their histories, too. Talk to them,
listen to them. They are alive poems.
Remember the wind. Remember her voice. She knows the
origin of this universe. I heard her singing Kiowa war
dance songs at the corner of Fourth and Central once.
Remember that you are all people and that all people
are you.
Remember that you are this universe and that this
universe is you.
Remember that all is in motion, is growing, is you.
Remember that language comes from this.
Remember the dance that language is, that life is.
Remember.*

JOY HARJO

Mnemosyne in the Modern World

JOY HARJO

I was the first born, arrived with great difficulty to this tempestuous love, this shaky sea. I was born during a new moon, a moon that represents new beginnings, the direction East. East is the harbor for those spirits who point us on our journey. East is the direction of our tribal homelands, the place of forced exile a few generations ago—in the southeast of this continent, made of nearly tropical foliage, water, and thick with animal power. My birth contradicted the prediction of destruction, the myth of the vanishing Indian that was bought and sold by the American public, for if we disappeared guilt would vanish, and the right to the land by strangers would be sealed. Though we lost over half the tribe during the forced walk from a land that had nurtured our people through millennia, we didn't die. I was the next loop in the spiral of memory.

JOY HARJO
The Poet's Notebook

Joy Harjo, who was born to a Creek father and a French-Cherokee mother, grew up in Oklahoma. She says that when she writes, she is often guided by the voice of an old Creek Indian within her. She writes poignantly about

her Native American culture—and the stereotypes that have defined it—but her concerns of personal survival and freedom have universal appeal. She often performs her poems—and plays the saxophone—with her band, Poetic Justice. She teaches at the University of Arizona in Tucson.

BILL MOYERS
The Language of Life: A Festival of Poets

the NINE MUSES

calliope

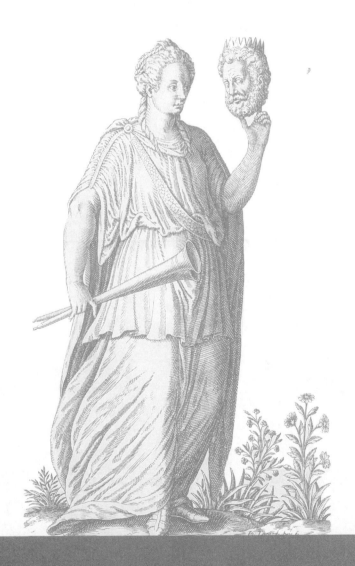

muse of eloquence and epic poetry

A poem . . . begins as a lump in the throat, a sense of

wrong, a homesickness, a lovesickness. . . . It finds the

thought and the thought finds the words.

ROBERT FROST

Historically, we do not know the exact birth order of the Muses. We only know that Calliope is the oldest of all her sisters. Her name means "fine, strong voice," and she is often portrayed holding large trumpets, stringed instruments, or poetic scrolls and tablets. She gave birth to Orpheus, who became Greece's celebrated singer of Thrace.

Calliope is considered the most eloquent and accomplished of the Muses because of her remarkable ability to synthesize all known forms of poetry, song, and music into the origination of dramatic presentations known as epic poetry. Epic poems often tell the story of cultural values and the beginnings of a journey—of a country, a race, or a hero. Through epic poetry, Calliope preserves the great stories and long tales full of many heroic figures and challenging plots. For her, poetry is a means of capturing the essence and beauty of a person's courageous journey. The *Illiad,* the *Ramayana,* and the *Song of Roland* are a few examples of Calliope's influence in the world.

Calliope saw epic poetry, theater, and narrative as a vehicle for the transmission of cultural information in primarily oral cultures. Hers is the dream that all peoples of the world would have narrative poems and stories. She formatted an effective method of transmission by using memory aids such as repetition, gestures, pauses, and standard phrases, so that audiences, as well as performers, would have time to integrate and remember the plot, characters, and values reflected in the epic poem or story. As Robert Pinsky, poet laureate, says, "This opening up, the discovery of much in little, seems to be a fundamental resonance of human intelligence . . . this passage to vast complexities is at the essence of what writing . . . might become."

Calliope inspired excellence and made sure that in epic poetry those who spoke attended to tone, mood, image, in order to bring beauty and eloquence into the form of what was being expressed. She felt that poetry and narrative should be enthralling, gripping, and moving. She taught variances in rhythm, voice tone, and volume—all tools that are important in the work of ex-

Fairy tales—the great difference is between doing something, and doing nothing. Always, in such tales, the hero or heroine does something.
MARY OLIVER

ceptional poets and storytellers. Calliope's precision of varied rhythms, images, and storytelling are apparent in Christina Rossetti's poem "Goblin Market," an exceptional balladlike narrative poem of 567 lines.

Calliope's mastery was the use of poetry and storytelling as performance art. Broadway director Julie Taymor carried Calliope's mastery into the costume, mask, and puppet design for the current theatre production of *The Lion King.* You can see Calliope at work more and more every day—at local poetry slams, storytelling festivals, bookstore readings, and poetry reading groups. Calliope has worked through poet laureate Joseph Brodsky, who seeded the American landscape with his American anthology of poetry, *101 Great Poems,* which is handed out every April (National Poetry Month) by his American Literary Poetry and Literacy Project.

The Greek epic poets held the ultimate poetry slams—hours and hours of heroic tales recited from memory to audiences with few distractions. In Greece, epic poetry was considered the most eloquent form of storytelling; and it became the foundation of all other poetry. For several centuries no other forms were cultivated. The Greeks especially valued epic poetry because of its ability to inspire creativity and to teach character development and historical values and to improve contemporary culture. Homer, Apollonius, Virgil, Plato, Socrates, and Aristotle communicated and transmitted most of their philosophies through epic poetry, poetic prose, theatre, and music. As a result, much of Greek culture was transmitted through poetry and storytelling accompanied by music.

> If a poem is written well, it was written with the poet's voice and for a voice. Reading a poem silently instead of saying a poem is like the difference between staring at sheet music and actually humming or playing the music on an instrument.
>
> ROBERT PINSKY, 39TH POET LAUREATE
> OF THE UNITED STATES

The Greek word for "distinguished" also meant "musical and poetic." In Greek religious practice it was believed that the Muse Calliope protected all who loved music and poetry. She was always evoked before a poet would recite or sing an epic poem, because poets believed that Calliope could help them deliver exceptional narrative performances that people would find meaningful and would long remember. Her presence is found in our world when she stirs the poetic imagination within men and women to make them great poets, bards, and storytellers—people like Shakespeare, Hans Christian Andersen, George Lucas, Maya Angelou, Charles Dickens, and Akira Kurosawa have been strongly influenced by this Muse.

There is more than just epic poetry, though. Calliope's influence is found in all the forms of poetry—such as sonnets (Shakespeare), beat poetry (Allen Ginsberg, Jack Kerouac, etc.), haiku, tanka, children's poetry, cowboy poetry, science fiction poetry, and regional and cultural poetry. Poetry takes many forms and outlets. Cowboy poetry, for example, expressed through plain and straight delivery, evokes the authentic life lived by many in the American West and rural areas. Many cowboy poets and ranch women are dedicated to preserving this style of poetry.

Rita Dove, the youngest person ever to become poet laureate of the United States, showed Calliope's range by bringing a program of poetry and jazz to the Library of Congress's literary series, along with a reading by young Crow Indian poets and a two-day conference entitled "Oil on the Waters: The Black Diaspora."

BRINGING CALLIOPE INTO YOUR LIFE

Write your own invocation to bring
Calliope into your life:

Invocation

O Calliope, keeper of storytelling wisdom
 and performance artistry,
Share your gifts of poetic eloquence
 and narrative enchantment with me,
Teach me the tools that evoke
 creativity and imagination.
Show me how to weave collective experience
 into timeless stories that teach,
 heal, and inspire us to learn, grow and change.
Let me open to the story that I live.
May our journeys serve future generations.

Poetry can be fun or serious; it can heal; it can be controversial, folksy, and inspirational. You can see Calliope at work in this small sampling of individuals who have received the Pulitzer Prize for Poetry: Mark Strand (1999), Charles Wright (1998), and Lisel Mueller (1997). Winners of the Nobel Prize in Literature include Günter Grass (1999), Seamus Heaney (1995), Nadine Gordimer (1991), and Octavio Paz (1990). Calliope's

presence in the modern world is dynamically expressed in Poets' Corner, a website housing the largest, most diverse public library of poetic works ever assembled.

Make a Muse Collage or Bulletin Board for Calliope

If you have room in your office, make a corkboard altar with poems, poets, pictures, favorite inspirational quotes, and even small objects that will evoke Calliope's spirit whenever you are looking at it—and even when you're not.

Calliope holding one of her epic poems in tablet form as she recites.

Reflections:

> With a great poet the sense of beauty overcomes every other
> consideration, or rather obliterates all consideration.
> JOHN KEATS

1. Dialogue with this Muse of Eloquence and Poetry. Ask Calliope how you can bring more beauty into your life and how she can guide you to the poetic aspects of your life.

Modern Calliope in America

- Larry D. Rinehart originated the Epic Poetry Project and started the American epic poem *America Liberata* in 1976 around the bicentennial of the Declaration of Independence. It has been growing steadily, at about one book every two years, and currently stands at ten books completed, of thirteen projected. http://home1.gte.net/conewago/epicpo.htm.
- Reread Henry Wadsworth Longfellow's epic poem *Hiawatha*.

Seven Ancient Epics

- The *Nibelungenlied* from medieval Germany
- The *Aeneid* from ancient Rome
- The *Song of Roland* from France
- The *Gilgamesh Epic* from ancient Sumeria
- The *Illiad* from ancient Greece
- The *Ramayana* from India
- The *Sundiata* from old Mali

Request her help to remember the stories and poetry you have loved, and what parts of your own story you love. Write down this conversation. What inspires, challenges, surprises, and touches you about the stories and poetry you loved in childhood and the current stories you love?

> Too many poets are insufficiently interested in story. Their poems could be improved if they gave in more to the strictures of fiction: the establishment of a clear dramatic situation, and a greater awareness that first-person narrators are also characters and must be treated as such by their authors. The true poet, of course, is exempt from this. But many poets wrongly think they are lyric poets.
>
> STEPHEN DUNN, POET

2. Create an Idea Trap, or Muse Trap—a small pocket-size notebook you carry with you where you jot down creative ideas, projects, meaningful phrases, and sources of inspiration.

3. Go to a bookstore or library and browse through their poetry section. Look for an anthology on a subject that interests you—love, pets, the sea, war, nature—and jot down phrases, words, and authors that capture your imagination.

Play with poetic forms. Lyrics are fun and haiku are a delight. Both can be done as a daily Calliope activity or practice.

Borrow the PBS/Bill Moyers poetry series from the Public Library.

Go to the library for recordings of poetry being read by poets and performers. You can even listen to poetry being read on the Internet.

CREATE Your Own Collection
of Favorite Poetry and Poets.
Put Them All Into Its Own Special Binder,
Blank Book, or Computer File.

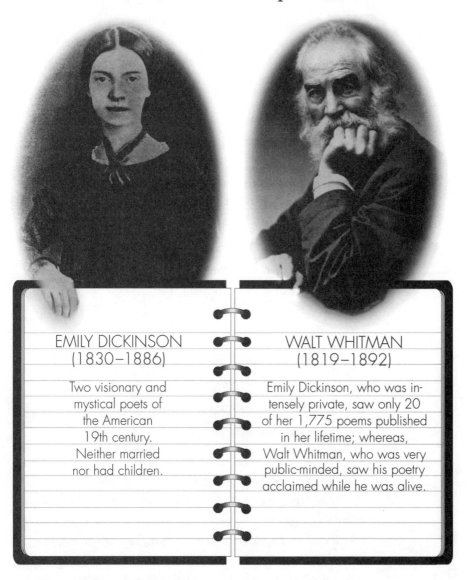

EMILY DICKINSON
(1830–1886)

Two visionary and
mystical poets of
the American
19th century.
Neither married
nor had children.

WALT WHITMAN
(1819–1892)

Emily Dickinson, who was in-
tensely private, saw only 20
of her 1,775 poems published
in her lifetime; whereas,
Walt Whitman, who was very
public-minded, saw his poetry
acclaimed while he was alive.

My greatest honor is that my work outlive me. I want to
write stories and poems and plays so profound that they will
be able to save people today and in the millennium to
come. This is an enormous challenge, but many, many
writers before me have done it. . . . I must welcome disci-
pline and criticism, and I must labor in confidence, not
conceit. I must listen and I must be willing.

SHIRLENE HOLMER, PERFORMER AND STORYTELLER;

HER SOLO BIOGRAPHICAL DRAMA *Conversation with a Diva*

WAS PRODUCED BY ACTORS THEATRE OF WASHINGTON, D.C.

4. Make storytelling a central part of your life. What stories
 do you tell to your children, loved ones, or friends?

- Begin to develop your repertoire of stories for a story-
 telling evening. What stories or epic themes would you
 want to explore? Make it a special and creative event in
 true Calliope style.

- Join the National Association for the Preservation and
 Perpetuation of Storytelling, P.O. Box 309, Jonesbor-
 ough, TN 37659, 615-753-2171, or attend this associa-
 tion's annual national storytelling conference.

5. Commit a poem to memory. Even a short quotation
 can be a source of comfort and inspiration.

6. Attend a poetry reading with a friend or loved one, or
 create a "poetry slam" where everyone brings ten of
 their favorites, or attend local poetry slam contests.

7. Write three poems: one to capture a precious memory
 in the past; one to capture the essence and love you have
 for a friend, family member, loved one, or colleague;
 and one to capture a powerful turning point in your
 life. Create an epic poem about your own courageous
 journey; or an epic poem that honors your roots or
 heritage. Add these to your collection of favorite poetry.

Calliope, a musical instrument also called steam organ or steam piano, in which steam is forced through a series of whistles controlled by a keyboard. It is usually played mechanically and its loud, shrill, and captivating sound is audible miles away. It was invented in the United States by A. S. Denny in 1850 and patented in 1855 by Joshua C. Stoddard. It was used to attract attention for circuses and fairs and was named for the Muse of Eloquence, who with instruments announced special events that would entertain and delight the Greeks.

"CANARY"

For Michael S. Harper

*Billie Holiday's burned voice
had as many shadows as lights,
a mournful candelabra against a sleek piano,
the gardenia her signature under that ruined face.*

*(Now you're cooking, drummer to bass,
magic spoon, magic needle.
Take all day if you have to
with your mirror and your bracelet of song.)*

*Fact is, the invention of women under siege
has been to sharpen love in the service of myth.*

If you can't be free, be a mystery.

RITA DOVE

calliope in the modern world

RITA DOVE

I couldn't live without my notebooks. I collect them like
fetishes: my favorites are black-and-red bound notebooks
that come in a variety of sizes from the People's Republic of
China. Into my notebook goes anything that is interesting
enough to stop me in my tracks—the slump of a pair of
shoulders in a crowd, a newspaper entry, a recipe, "chewy"
words like ragamuffin or Maurice. I refer to my notes (on
my desk right now are over fifteen different notebooks) at
the start of each writing day: sometimes I copy several en-
tries onto a sheet of lined notebook paper just to see how
they work together. Poems evolve slowly, in spurts and
sputters, on these college-ruled pages; a small stack of
notebooks is always at the ready for browsing. For me, it all
begins with a notebook: it is the well I dip into for that first
clear, cool drink.

RITA DOVE
The Poet's Notebook

Rita Dove teaches at the University of Virginia. Her poems in *Thomas and Beulah* about imagined moments in the lives of her maternal grandparents won the Pulitzer Prize in 1987. She became the first African American to be designated poet laureate of the United States—and, at forty-one, the youngest to hold that position (1993–1994).

clio

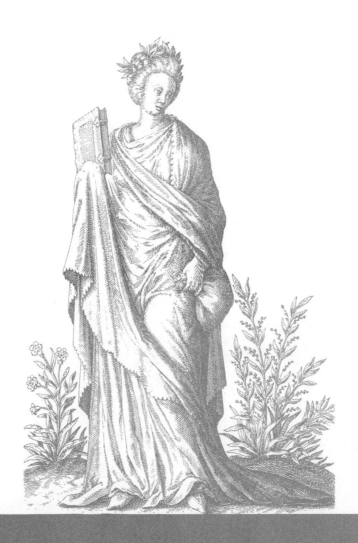

muse of history and writing

The historical telling satisfies one of the most basic of human needs—to know what happened and why. What does the telling of history celebrate? What motive shapes its telling? What "truth" does history give? Because these questions pertain to qualities and limits of knowledge, one can see why tradition has given history its Muse, a shaping inspiration, connected with a divine or imperishable knowledge.

EILEEN GREGORY
The Muses

The word *history* comes from the Greek verb *historein:* to learn by inquiry, and to tell, record, or narrate what one has learned by inquiring. The Muse Clio, with her book and bag of seeds, is the scholar or researcher who ignites the desire to record, to investigate, and to give an account of events in time. Her name comes from the Greek verb *kleiein,* or *klein:* to tell, and thus to celebrate, to make memorable.

Clio reminds us that history is a way for the human spirit to leave a legacy of learnings, to record what happened, what had meaning, what worked, and what did not work. Writer John Irving describes the challenge of writing history: "For history, you need a camera with two lenses—the telephoto and the kind of close-up with a fine, penetrating focus. You can forget the wide-angle lens; there is no angle wide enough." Historical records provide a platform or bridge where our experiences of records of the past can stimulate new conversations in the present to create and envision a meaningful future. History is a way of leaving a record, a way of remaining after we are gone, a way of touching immortality. Clio's presence is powerfully expressed through the well-known historians William Leuchtenburg, Doris Kearns Goodwin, Arthur Schlesinger, Jr., Mary Ritter Beard, Arnold Toynbee, Thomas Carlyle, and David Hume, to name a few. Noted writer and art historian Kenneth Clark was seized by Clio's influence for two years as he created his production *Civilization.*

Besides recording historical events and facts, Clio's presence is the one that ignites all memoirs, autobiographies, diaries, biographies, and teaching stories. James Olney in his book *Autobiography and the Cultural Moment* writes: "Is it not perhaps more relevant to say that the autobiographer half discovers, half creates a deeper design and truth than adherence to historical and factual truth could ever claim to?" As early as 1870, at the age of thirty-six, Mark Twain envisioned his autobiography. His project went through many stages, including a number of years at the end of his life when he dictated and dedicated his memoirs to a stenographer. All of these written and oral forms hold the conversations we have with our-

When I don't write, I feel my world shrinking. I feel I am in a prison. I feel I lose my fire and my color. It should be a necessity, as the sea needs to heave, and I call it breathing.
ANAÏS NIN

selves about the meaning of our life experience. Biographical writers such as Judith Thurman, Richard Ellmann, Leon Edel, Joseph Frank, and Justin Kaplan demonstrate Clio's gift of tracking the meaningful experiences and conversations found in the lives of others. Those conversations, no matter what biographical or autobiographical language we use, are the philosophical, theological, and historical ways we capture events, facts, ideas, meaning, imagination, myth, and memory in our lives.

Clio enters our world when we attempt to recapture and integrate our experiences in writing. The Latin phrase used by scribes in the Middle Ages was *pono eum in scribendum* (put it in writing). Writing is a way we can discover and express different realities and experiences—whether it is writing mysteries, science fiction, screenplays, or short stories. For a writer's life is his or her poetry or books, as is so well expressed in Annie Dillard's

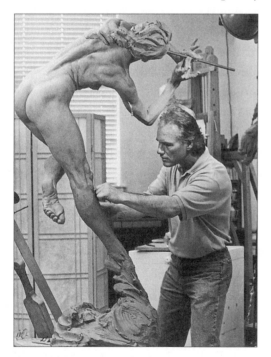

The Muse Clio trumpets into Richard MacDonald's California studio, where he is sculpting "Trumpeter," one of his many beautiful Muse-like feminine sculptures.

book *The Writing Life.* Henry David Thoreau, after writing his memoir *Walden,* discouraged some admirers from visiting him by saying, "You may rely upon it, you have the best of me in my books." Writing becomes a vehicle for meaningfully expressing what we see, feel, and understand about our life experiences both personally and collectively. Writer Natalie Goldberg reveals Clio's primary secret about why we are motivated to put our experiences into writing: "The deepest secret in the heart of hearts is that we are writing because we love the world."

Clio insists that every writer, scribe, and historian bring forward his or her own voice to braid together memory, fact, and imagination. To cultivate one's voice and bring it into writing requires the capacity for inner listening, which is a necessary and essential prerequisite for creativity and honest expression. Poet Li-Young Lee, winner of the Lamont Poetry Prize in 1990, writes: "In writing poetry, all of one's attention is focused on some inner voice." It is this inner voice that prompts the emergence of old memories, solid

facts, and evocative images to be chosen or denied for creative expression. Writers like Toni Morrison, E. L. Doctorow, Louise Erdrich, Maxine Hong Kingston, Gabriel García Márquez, Bharati Mukherjee, Barbara Kingsolver, and Wallace Stegner have all woven cultural memory, facts, images, and deep listening together. Clio asks us to sort our life experiences into meaningful clusters and record what might teach and inspire ourselves and

BRINGING CLIO INTO YOUR LIFE

Write your own invocation to bring Clio into your life:

Invocation

O Clio, exquisite record-keeper
 of life's blessings and learnings,
Guide me today as I put my
 words into written form.
May I creatively capture what has
 touched me.
Help me open to the words and sentences
 that can best share
 my experiences accurately.
Move me to join my heart for
 wise expression in all that
I might write today.

others. She reminds us that historical and timeless records or writing of any kind will sustain itself only if it has practical and timeless relevance for the human spirit.

MAKE A MUSE COLLAGE OR BULLETIN BOARD FOR CLIO

Looking for pictures I found dozens of letters and post-cards to my grandparents, and my grandmother's annotations, and the Sunday school program, 1931, when I first went to Sunday school, with the crayoning I did there, and my mother's postcard to my grandmother after I got home telling how I talked all the time about New Hampshire. I was brought up to love New Hampshire! There's a postcard I wrote to my grandparents about Fluffy and another, 1944, about the death of my blind chick. Typed letters from Exeter talk about track, busyness, poems in magazines.

DONALD HALL, POET

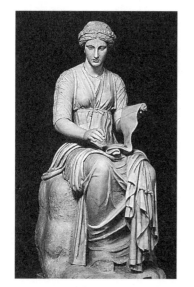

Clio with her historical recording scroll.

REFLECTIONS:

History's most conspicuous feature is active change.
JACQUES BARZUN

1. Create a space in your library, office, or workroom that honors your Muse of Writing and History. Select a spe-

cial place in your Muse Journal or create a computer file that can be used for Clio inspirations. Ask her for guidance on a current writing project or letter that is important for you to write.

"WOMEN"

They were women then
My mama's generation
Husky of voice—Stout of
Step
With fists as well as
Hands
How they battered down
Doors
And ironed
Starched white
Shirts
How they led
Armies
Headragged Generals
Across mined
Fields
Booby-trapped
Ditches
To discover books
Desks
A place for us
How they knew what we
Must know
Without knowing a page
Of it
Themselves.

ALICE WALKER

2. What parts of general history have you been fascinated by or have appeared in your dreams? What other cul–

Modern Clio Examples

National Writing Project
- Teaches writing and improves learning in nation's schools
- Seeks to promote exemplary instruction of writing in every classroom in America as a basic right to all learners regardless of race, gender, class, ethnicity, or language

Memories to Memoirs
Helps thousands of people to preserve their stories in written autobiography. How would you like yours preserved?

The Gutenberg School Scribes
Offers ways modern scribes can resource and apply old methods of making scrolls. Make a scroll honoring a favorite moment.

All have websites.

See the bibliography.

tures have you visited or read about? Write one page in your journal that would describe your favorite part of history or favorite culture. Why not create a collage in your journal of pictures, maps, images of this culture? Writer Annie Dillard captures some of the cultures, seasons, or places that have influenced some of our well-known authors in her book *The Writing Life:*

Write about winter in the summer. Describe Norway as Ibsen did, from a desk in Italy; describe Dublin as James Joyce did, from a desk in Paris. Willa Cather wrote her prairie novels in New York City; Mark Twain wrote Huckleberry Finn in Hartford, Connecticut. Recently, scholars learned that Walt Whitman rarely left his room.

3. What historical person and contemporary person have had the most impact on your life (for example, someone like Joan of Arc or Mother Teresa, or others you might want to explore)? What are the similarities between these two? What are the differences? Why not try to have a dialogue between them? How about writing a poem about them or memorizing a quote by them?
Drawing a picture of them?

4. What relationship do you have to writing? To what kind of writing have you been drawn? What biographies do you enjoy reading? Create a Clio "history evening" with friends and family—ask each person to bring a favorite biography, or share with each other the parts of history that are most captivating for everyone and why.

5. Keep a journal or notebook as a way of capturing your ideas, feelings, images, and memories. This has long been a Clio practice throughout time.

Much could be said about the notebook. Tchaikovsky would scribble down a melody on the first piece of paper that came

to hand. French painter Toulouse-Lautrec would take out his sketch pad at any moment, during a walk or in the middle of a conversation, jot down a few lines for a second or two, and then return it to his pocket. Another French painter, Georges Braque, always kept an exercise book within reach so that he could seize any thought that passed through his mind and record it. He said that his sketch pad was as useful to him as a cookbook when one wants to prepare food: he would open it and the smallest sketch would provide him with the starting point for a painting.

Beethoven jotted down in notebooks his musical ideas, but often made use of any scrap of paper available, even a restaurant bill. Most of the musical ideas jotted down in his notebook never materialized into a significant work. As one leafs through them, wrote his biographer Alexander Thayer, one discovers countless compositions in draft form, musical masterpieces that have remained in the limbo of the unfinished. PIERO FERRUCCI
Inevitable Grace

I love reading poets' notebooks. Poets are curious critters, and it is a pleasure to relax with the jottings and musings of the other practitioners. ANSELM HOLLO, POET

6. Notice Clio's professions in the modern world, listed here—which ones do you practice, support, or admire? If you are involved in any of these activities this week, create an invocation to Clio to elicit her help and support; or write an editorial or send a letter to the newspaper acknowledging someone or something in the community.

- Court reporters
- Stenographers
- Editors and reviewers
- Calligraphers

- Technical writers and editors

- Typeset designers

- Publishers

- Historians

- Writing on genealogy

- Public relations specialists

- Document and business designers

- Corporate and educational trainers

- Information designers

"BENEATH THE SHADOW OF THE FREEWAY"

We were a woman family:
Grandma, our innocent Queen;
Mama, the Swift Knight, Fearless Warrior.
Mama wanted to be Princess instead.
I know that. Even now she dreams of taffeta
and foot-high tiaras.

Myself: I could never decide.
So I turned to books, those staunch, upright men.
I became Scribe: Translator of Foreign Mail,
interpreting letters from the government, notices
of dissolved marriages and Welfare stipulations.
I paid the bills, did light man-work, fixed faucets,
insured everything
against all leaks.

LORNA DEE CERVANTES

7. Review your life by decades. What are the events, places, people, animals, surprises, important decisions, and internal experiences that have shaped or changed your

life? Use the chart on this page as a model for a chart
you can make to hold your appropriate notations. After
you have filled out your chart, consider these activities
to deepen your discoveries.

· Select and list five critical events from your chart, espe-
 cially the ones without which you would absolutely have
 become a different person from who you are.

· Choose the most significant material to write about
 first—either in letter form, story, poetry, autobiographi-
 cal memoir, journal format, or historical news release.

Some events that might appear on your chart could be:

· Birth of children

· Mistakes, failures

· Marriage/divorce

· Travel, adventures,
 other cultures

· Religious, spiritual
 experiences

· Important relation-
 ships

· Illness, deaths, losses

· Accidents, floods, fires

· Conflicts

· Career choices and
 changes

SAMPLE OF LIFE CHART BY DECADES

1-10	11-20	21-30	31-40	41-50	51-60	61-70	71-80...

- Name five things or ways of being for which you would like to be remembered. (*Recorder:* to remember; from the Latin *recordis,* to pass back through the heart.) Enter these into your Clio journal/notebook or computer file.

- Read *Legacy: A Step-by-Step Guide to Writing Personal History,* by Linda Spencer.

For deeds do die, however nobly done,
And thoughts of men do as themselves decay,
But wise words taught in numbers for to run,
Recorded by the Muses, live for ay.

EDMUND SPENSER
The Ruines of Time (1591)

Shortly after my father died in 1972, the fatal heart attack coming as he watched a Mets game on television, I married and began to raise a family of my own, finding myself re-enacting many of the rituals I had shared with my father. I took my oldest son, Richard, to spring training, and watched with an almost jealous pride as the generous Jim Rice let him feed balls into the pitching machine while the All-Star slugger took batting practice. I taught my two youngest sons, Michael and Joe, how to keep score, bought season tickets, and took them to dozens of games every year.

Sometimes, sitting in the park with my boys, I imagine myself back at Ebbets Field, a young girl once more in the presence of my father, watching the players of my youth on the grassy fields below—Jackie Robinson, Duke Snider, Roy Campanella, Gil Hodges. There is magic in these moments, for when I open my eyes and see my sons in the place where my father once sat, I feel an invisible bond among our three generations, an anchor of loyalty and love linking my sons to the grandfather whose face they have never seen but whose person they have come to know through this most timeless of sports.

DORIS KEARNS GOODWIN
Wait Till Next Year: A Memoir

clio in the modern world

DORIS KEARNS GOODWIN, HISTORIAN

Doris taught for ten years at Harvard University as professor of government. She was an assistant to President Lyndon Johnson during his last year in the White House, and later assisted him on the preparation of his memoirs. In 1987 her book *The Fitzgeralds and the Kennedys* won the Literary Guild award and was a *New York Times* bestseller for five months. Her next success was *No Ordinary Time: Franklin and Eleanor Roosevelt: The American Homefront during World War II,* which was awarded the Pulitzer Prize for history in 1995. *Wait Till Next Year: A Memoir,* her tale of growing up in the 1950s and her love of the Brooklyn Dodgers, was published in 1997; it became a *New York Times* bestseller. "This is a book in the grand tradition of girlhood memoirs, dating from Louisa May Alcott to Carson McCullers and Harper Lee," the *Washington Post* reviewer wrote.

ERATO

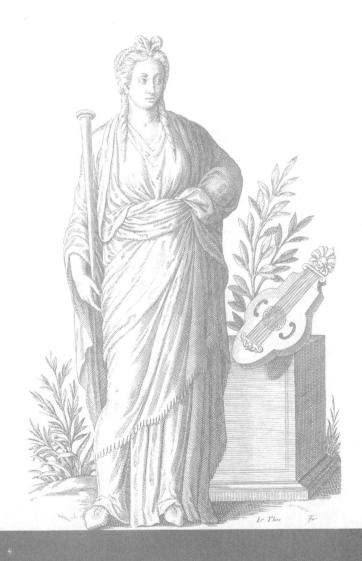

MUSE OF LOVE POETRY

How do I love thee? Let me count the ways.
I love thee to the depth and breadth and height
My soul can reach, when feeling out of sight
For the ends of Being and ideal Grace.
I love thee to the level of everyday's
Most quiet need, by sun and candle-light.
I love thee freely, as men strive for Right;
I love thee purely, as they turn from Praise.
I love thee with the passion put to use
In my old griefs, and with my childhood's faith.
I love thee with a love I seemed to lose
With my lost saints—I love thee with the breath,
Smiles, tears, of all my life!—and, if God choose,
I shall but love thee better after death.

ELIZABETH BARRETT BROWNING
Sonnets from the Portuguese

Erato, with her scepter and stringed instrument, is the Muse who awakens the heart to express love creatively and who announces the presence of love in our lives. She is the custodian of the four kinds of love that have been identified in Western tradition: eros, the drive to unify, to create and pro-create; and the urge toward higher forms of being and relationship; libido, physical desire, sexuality, sensuality, lust; Philia, friendship or brotherly and sisterly love; and agape or caritas, the compassionate heart or transfigured desire, the love devoted to the respect and welfare of others, the commitment of doing no harm nor making inappropriate transgressions. Every human experience of authentic love is a blending in varying proportions of these four. The Dalai Lama reminds us of the importance of love's expression when he says, "Love and compassion are necessities, not luxuries. Without them, humanity cannot survive."

Erato is the specific Muse who mediates between all forms of love and the human and spiritual experience of expressing love fully. She is often considered to be the emissary of Eros. The ancients made Eros a "god," or, more specifically, a *daimon,* which is any natural force that has the power to take over the whole person. This is a symbolic way of communicating a basic truth of human experience—that Eros always drives us to transcend ourselves in the experience of love. Poet Charles Simic writes about Erato's power when he says, "Imagination equals Eros. I want to experience what it's like to be inside someone else in the moment when that someone is being touched by me." Erato reminds us that love of any kind is a spirited power that binds all things and people together and generates inward change and outward healing. Love incites within the human spirit the yearning for knowledge and for passionately seeking a union with truth. Erato draws us to what and whom we love. She shows us that through love not only can we become poets and inventors but we can touch our ethical goodness and unlimited creativity as well.

Through her love poetry and creativity, Erato demonstrates love's need to be creatively expressed. She makes her presence

Love is a canvas furnished by Nature and embroidered by imagination.
VOLTAIRE

known to us in our world when we are seized by the desire to creatively express the love that is in our hearts. Her insistent proddings to express what we are learning about love are found in the most prevalent love themes that have been poetically and creatively expressed worldwide. Diane Ackerman identifies these universal themes in her book *Natural History of Love.* Shakespeare is the one prolific writer who thoroughly explored all the universal themes of love. Erato's influence can be seen in the other poets, speakers, or writers listed here for each theme (naming only two examples of many who may come to mind).

- Love's alchemy or power to transform or improve one's nature (Simone Weil, C. S. Lewis)

- Praising the beloved in images drawn from nature (Wallace Stevens, Annie Dillard)

- Love as a fortifying or disturbing experience (Anne Sexton, George Trakl)

- Love as a kept secret or private longing (William Yeats, Emily Dickinson)

- Love as a heightening of one's gifts and senses (Elizabeth Barrett Browning, Robert Browning)

- Love as a gift of friendship (Gertrude Stein, May Sarton)

- Love as a passion and burning physical fire (Anaïs Nin, Henry Miller)

- Love as an expression of human compassion (the Dalai Lama, Mother Teresa)

- Love as embracing the reverence of anything spiritual, numinous, and mysterious (Rumi, Saint Theresa of Avila)

Henry Miller and Anaïs Nin.

In ancient Greek physiology and in biblical psychology, the heart was the organ of sensation. It is also the place of imagination. The common sense (*sensus communis*) was lodged in and around the heart, and its role was to apprehend meaningful images. William Butler Yeats captures the mandate of the Muses for spirited and heartfelt creativity in this excerpt from the poem "Those Images":

> Seek those images
> that constitute the wild,
> the lion and the virgin,
> The harlot and the child,
>
> Find in middle air
> An eagle on the wing,
> Recognize the five
> That make the Muses sing.

Erato's presence in Yeats's poem reminds us that the creative heart requires us to be strong-hearted (like the lion), open-hearted and curious (like the virgin), trusting of our instincts and expe-

LOVE"

Once upon a time, there was an island where all the feelings lived: Happiness, Sadness, Knowledge, and all of the others, including Love. One day it was announced to the feelings that the island would sink, so all repaired their boats and left. Love was the only one who stayed. Love wanted to persevere until the last possible moment. When the island was almost sinking . . . Love decided to ask for help. Richness was passing by Love in a grand boat. Love said, "Richness, can you take me with you?" Richness answered, "No, I can't . . . there is a lot of gold and silver in my boat. There is no place here for you." Love decided to ask Vanity who was also passing by in a beautiful vessel, "Vanity, please help me!" "I can't help you, Love . . . you are all wet and might damage my boat," Vanity answered. Sadness was close by so Love asked for help, "Sadness, let me go with you." "Oh . . . Love . . . I am so sad that I need to be by myself!" Happiness passed by Love too, but she was so happy that she did not even hear when Love called her! Suddenly, there was a voice, "Come, Love, I will take you." It was an elder. Love felt so blessed and overjoyed that he even forgot to ask the elder her name. When they arrived at dry land, the elder went her own way. Love, realizing how much he owed the elder, asked Knowledge, another elder, "Who helped me?" "It was Time," Knowledge answered. "Time?" asked Love. "But why did Time help me?" Knowledge smiled with deep wisdom and answered, "Because only Time is capable of understanding how great Love is."

ANONYMOUS

riences (like the harlot), willing to discover and explore (like the child) and to express and manifest what we see (like the eagle) in an integrated way (the middle air).

For Erato, poetry holds songs, images, and stories that explore themes from the heart and soul. She guides poets like Robert Bly to also translate other poets of passion—Neruda, Kabir, Machado, Rilke, and Juan Ramon Jimenez, and she also seized poet Coleman Barks and inspired him to be one of the major translators of the twelfth-century Persian poet Rumi. Erato's love poems require authentic soul expression from the heart. She reminds us that having the courage to reveal one's inner feelings is, in fact, a sign of maturity. The creative force of Eros requires that we dismantle the false self in order to birth a truer self. Erato asks us to risk ourselves and helps one become able to say yes to oneself. Vietnamese poet Nguyen Chi Thien captures what happens when Erato awakens us from any place where we have settled for less in our life with these haunting lines: "But who are you? The minute I saw you / I felt a sorrow I could not escape. / Your eyes revived so many thirsts / I thought I'd smothered long ago." Erato requires that we live a full-hearted life, which is the mandate of the soul. Her presence is found in all matters of the heart, for she prompts all expression of love in the world. She is the mysterious force that ignites Plato's truth that love is the pursuit of the whole.

BRINGING ERATO INTO YOUR LIFE

Write your own invocation to bring
Erato into your life:

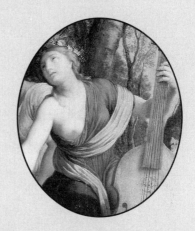

Invocation

O Erato, guardian and steward
 of love's mystery,
Keep my heart open, strong,
 full, and clear.
Open me to the heart's eternal fire!
Entrust me with the gifts of
 friendship, family, and partnership,
Ignite honest and creative expression
 in my love nature,
Let me never forget love's power to heal.

"A THIRD BODY"

A man and a woman sit near each other, and they do not long
at this moment to be older, or younger, nor born
in any other nation, or time, or place.
They are content to be where they are, talking or not-talking.
Their breaths together feed someone whom we do not know.
The man sees the way his fingers move;
he sees her hands close around a book she hands to him.
They obey a third body that they share in common.

They have made a promise to love that body.
Age may come, parting may come, death will come.
A man and a woman sit near each other;
as they breathe they feed someone we do not know,
Someone we know of, whom we have never seen.

ROBERT BLY

MAKE A MUSE COLLAGE OR BULLETIN BOARD FOR ERATO

Pictures, people, animals, and places of the heart shout out
what we really care about! WILLA CATHER

REFLECTIONS:

What the world really needs is more love and less paperwork.
PEARL BAILEY

1. For one hundred days, take an action every day that
 brings more love into the world—acts of service, grati-
 tude, acknowledgment, and joy that relieve suffering.
 Volunteer for one day at a school; make meals for the
 elderly; sing or read to sick children; or help a friend

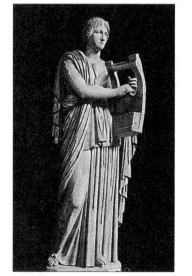

Erato, with her stringed instrument, evokes
the heart.

or loved one. Ask Erato to help you creatively express love for the one hundred days you select.

THE MANYŌSHŪ

The *Manyōshū*, or "Collection of Ten Thousand Leaves," is the oldest and most revered of the Japanese anthologies. Compiled in the middle of the eighth century, it includes about forty-five hundred poems, many by members of the court aristocracy. Women are well represented and among the most celebrated of the *Manyōshū* poets.

LADY KASA (EIGHTH CENTURY)

Twenty-nine of her tanka, all addressed to the great *Manyōshū* poet Otomo Yakamochi, are included in the *Manyōshū*.

> *To love someone*
> *Who does not return that love*
> *Is like offering prayers*
> *Back behind a starving god*
> *Within a Buddhist temple.*

TRANSLATED FROM THE JAPANESE
BY HAROLD P. WRIGHT

Helena Villagra dreamed that the poets were entering the house of words. The words, kept in old glass bottles, waited for the poets, and offered themselves, mad with desire to be chosen: they begged the poets to look at them, smell them, touch them, lick them. The poets opened the bottles, tried words on their fingertips and smacked their lips or wrinkled their noses. The poets were in search of words they didn't know as well as words they did know and had lost.

In the house of words was a table of colors. They offered themselves in great fountains and each poet took the color he needed: lemon yellow or sun yellow, ocean blue or smoke blue, crimson red, blood red, wine red.

EDUARDO GALEANO
The Book of Embraces

2. Who have been the teachers of your heart? State their lessons in your own words. How will you apply that lesson today?

Make a collage or write a poem that holds these lessons and honors your teachers of the heart.

A joyful heart is the inevitable result of a heart burning with love.
MOTHER TERESA

3. Write a love poem or love letter that demonstrates one
 of the universal themes addressed in love poetry (see
 page 66) to someone or someplace important in your
 life; or memorize a classic love poem from a favorite
 poet, or from *Romeo and Juliet* or one of Shakespeare's
 sonnets.

Did you preserve your flesh in each bone? The mystery of
love was hidden completely in the prudence of your black
gloves. LÓPEZ VELARDE

Consult a great Erato resource, *The Laugh and Cry Movie Guide,* by
Cathie Glenn Sturdevant, which shows you how to use movies to
help yourself through life changes and relationship challenges.
Pick the films that would help your heart the most.

A museum's purpose is more than an accumulation. . . .
In that sense, the heart is just such a museum, filled with
the exhibits of a lifetime's loves. . . . The heart is a living
museum. In each of its galleries, no matter how narrow or
dimly lit, preserved forever like wondrous diatoms, are our
moments of loving and being loved. DIANE ACKERMAN
 A Natural History of Love

"UNFINISHED SONNET"

O you High Gods, have pity, and let me find
Somehow some incontestable way to prove
(So that he must believe it) my love
And this unwavering constancy of mind!
Alas, he rules already with no let
A body and heart which must endure
Pain and dishonor in a life unsure,
The obloquy of friends and worse things yet.

For him I would account as nothing those
Whom I named friends, put my faith in foes:
For him I'd let the round world perish, I
Who have hazarded both conscience and good name,
And to advance him happily would die . . .
What's left to prove my love always the same?

MARY STUART, QUEEN OF SCOTS

4. Name four relationships in your life that reflect the
 four kinds of love: eros, philia, libido, and agape.
 Create a Litany of Thanksgiving to these four people
 and say it every day for nine days.

- Eros—the drive to unify, to create and procreate; the
 urge toward higher forms of being and relationship.
 Identify in your Muse Journal who has been the most
 significant heart and creative connection you have
 experienced to date. These connections of heart and
 creativity are "uncommon bonds" that become trans-
 formative and life-changing experiences. Create a
 special tribute, gift, or card to send or give to this
 person.

- Philia—friendship or brotherly and sisterly love. Iden-
 tify in your Muse Journal who are the important friends
 and colleagues in your life who are like your own broth-
 ers and sisters or extended family to you. For one
 month, each week honor a friend by taking him or her
 to lunch or sending a special card of gratitude for the
 part he or she plays in your life.

- Libido—these relationships hold and experience the fire
 of sensuality, sexuality, and intense physical attractions
 and desire. Identify in your Muse Journal who is the

important person who has initiated you to different levels and experience of sensual awareness and the spontaneous and tender sexual expression of physical love. Honor this relationship in a creative way by communicating how much you respect the opening of love's physical expression you both have created for each other.

- Agape or caritas—the compassionate heart or transfigured desire, and the love devoted to the respect and welfare of others. Identify in your Muse Journal the people who have modeled or taught you about compassionate and unconditional love. For one week, practice agape—extend genuine compassion by initiating an action that will relieve suffering for a stranger, friend, colleague, or loved one.

I don't trust people until I know what they love. If they cannot admit to what they love, or in fact love nothing, I cannot take even their smartest criticisms seriously.

STEPHEN DUNN, POET

5. What would you like to deepen, soften, strengthen, and open in four important relationships that you have?

Create a special evening or experience for each relationship where you can initiate a conversation or dialogue surrounding what is calling to be strengthened, softened, deepened, and opened in the relationship from each other's perspective.

Speech is not the tongue, but of the heart. The tongue is merely the instrument with which one speaks. He who is dumb is dumb in his heart, not in this tongue. . . . As you speak, so is your heart.

PARACELSUS
IN *Saanii Dahataal:*
The Women Are Singing: Poems and Stories,
BY LUCI TAPAHONSO

"RAISIN EYES"

I saw my friend Ella
with a tall cowboy at the store
the other day in Shiprock.

Later, I asked her
Who's that guy anyway?

Oh Luci, she said (I knew what was coming).
It's terrible. He lives with me.
And my money and my car.
But just for awhile.
He's in AIRCA and rodeos a lot.
And I still work.

This rodeo business is getting to me
you know and I'm going to leave him
because I think all this I'm doing now
will pay off better somewhere else
but I just stay with him and it's hard
because

he just smiles that way you know
and then I end up paying entry fees
and putting shiny Tony Lamas on lay-away
again.
It's not hard.

But he doesn't know when
I'll leave him and I'll drive across the flat desert
from Red Rock in blue morning light
straight to Shiprock so easily.

And anyway
my car is already used to humming
a mourning song with Gary Stewart
complaining again of aching and breaking
down-and-out love affairs.

Damn.
These Navajo cowboys with raisin eyes
and pointed boots are just bad news
but it's so hard to remember that
all the time.

She said with a little laugh

LUCI TAPAHONSO

6. Write your own poem for
 someone who still lives in
 your imagination and heart
 after all these years.

"THE WOMAN AT THE PALACE OF THE LEGION OF HONOR"

She does not know that I am staring at her
as she stands in her bright yellow dress
looking at something by Rodin,
She does not know that I believe in the solemn
things sculpted by Rodin,
Looking like poetry
or the secret of clay.

If only I were brave and handsome,
I would let her hear my mind
as I equate her with the statue.
I don't think she has even glanced at me,
and here I am, so close by,
confused,
listening to Rodin,
And listening to the woman
who stand there.

Looking like poetry
or the secret of clay.

NEELI CHERKOVSKI

erato in the modern world

SOPHIA LOREN

> The two big advantages I had at birth were to have been
> born wise and to have been born in poverty.
>
> SOPHIA LOREN

Sophia Loren was born in Rome as Sofia Scicolone. She was
raised in poverty during the ravages and hardships of World War
II by her mother, a single parent. She met producer and future
husband Carlo Ponti while competing in a beauty contest. Ponti
gave her a screen test and advanced her career in a succession of
Italian productions. In 1952, Sophia became Sophia Loren and
came to the United States to sign a contract with Paramount for
her first English-speaking role. Her films with Marcello Mas-
troianni remain classics today.

Sophia Loren won an Oscar for the film *Two Women.* She is
considered by her colleagues to be not only very beautiful but
also an intelligent woman with a natural talent for comedic and
serious roles. She is reputed to have a great love for children and
is a person of deep faith. She received an honorary Oscar for
Lifetime Achievement in 1980. Besides acting, she is a passion-
ate cook and has authored two highly acclaimed cookbooks fea-

turing over one hundred recipes gathered from regions across Italy. Even today, at sixty-two, Sophia to the Italians is still *la forza*—the earth mother of us all. She now lives in the United States with her husband and two sons. She models the integration of the four kinds of love that Erato expresses.

euterpe

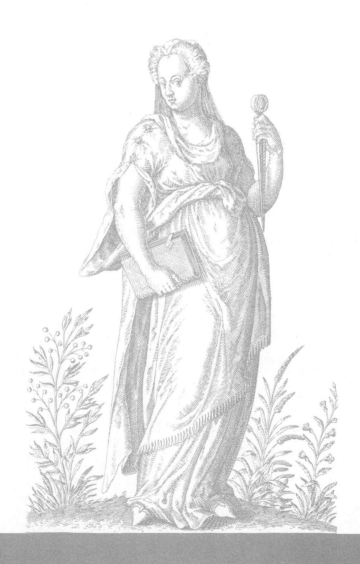

muse of music

Music begins
to atrophy
when it departs too far
from the dance . . .
poetry begins
to atrophy
when it gets too far
from the music.

EZRA POUND

uterpe, the Muse "who with her voice singing, makes herself beloved," announces the entry of beautiful music or song. She is accompanied by her song book and aulos, a flute with equidistantly drilled holes. Though the human voice was considered preeminent among the ancient Greeks and superior to any other musical instrument in its expressive power, it was always enhanced either by the aulos or the lyre. Opera singers of the world have explored the full range and power of the human voice—from Enrico Caruso and the three great tenors (Jose Carreras, Luciano Pavarotti, and Placido Domingo), to Marian Anderson, Renée Fleming, and Cecilia Bartoli, all have known Euterpe's influence. Maria Callas states Euterpe's purpose clearly: "When music fails to agree to the ear, to soothe the ear and the heart and the senses, then it has missed the point."

In Greece, the word "music" (*mousike*) was used virtually as a synonym for education. The first places of education were sacred groves where the presence of divine inspiration and natural beauty were most clearly felt. The first Greek philosophical school, founded by Pythagoras, was a religious guild dedicated to the Muses. This school is still famous for its philosophy of educating the whole person and its integration of scientific, spiritual, and artistic disciplines. Euterpe's education is best stated by modern entertainer and music educator Shari Lewis: "Findings show that preschool children who get fifteen minutes a week of private keyboard instruction, plus rote singing, at the end of eight months have a 46 percent higher spatial IQ. Spatial IQ is the kind necessary for math and science . . . learning an instrument teaches you how to learn." Today you will also find Euterpe's influence in this type of education at the Juilliard School of Music. This Muse's presence is especially seen in the work of Dorothy DeLay, who is still considered Juilliard's finest music teacher and carries an international reputation as such among the most reputed violinists in the world.

As the Muse of Music, Euterpe is both an educator and entertainer. She is the master synthesizer of ideas, feelings, and images produced in sound and music. Aaron Copland was clearly influenced by Euterpe when he wrote *What to Listen for in Music.* He

The Great Instrument is uncompleted.
The Great Tone has an inaudible sound.

LAO TZU
Tao Te Ching

offers provocative suggestions and a fascinating analysis of how to listen to music for deeper appreciation. Euterpe's transformational medium is the quality of sound and music that transports us into timeless worlds where we can connect, create, and unify beyond differences. Spanish cellist Pablo Casals recognized the powerful unifying force of music when he said,

> To see people gathered in the concert hall came to have important symbolic significance for me. When I looked into their faces, and when we shared the beauty of music, I knew that we were brothers and sisters, all members of the same family. Despite the dreadful conflicts of the intervening years and all the false barriers between nations, that knowledge never left me.

You can see Euterpe at work today in the broad global genres and range of music that is available not only in the musical exchange crossculturally but also in the widely accessible music categories such as jazz, country, rock, blues, pop, opera, classical, gospel, karaoke, and rap, to name just a few. Euterpe knows that music speaks to everyone and is a unifying language that ignites inspiration, feelings, and creativity.

Through music, Euterpe stimulates the unification of memory and the imagination within us. Composer and pianist Robert Jourdain writes in his book *Music, the Brain and Ecstasy: How Music Captures the Imagination* about why and how music affects us and why we enjoy some types of music and not others. His book illustrates Euterpe's purpose: to capture our feelings, ignite our imagination, and stir within us poignant memories. The Muse of Music mesmerizes, enchants, energizes, disturbs, and touches us while simultaneously sparking the experiences of delight, reverie, inspiration, play, reflection, and devotion.

Euterpe's influence is found in the opera *Carmina Burana,* a "scenic contata" by the composer Carl Orff, based on poems of anonymous thirteenth-century monks. Euterpe's presence is announced when we are moved to chant, hum, sing, or express ourselves poetically by writing songs. She teaches us that many

forms of song and music are compelling sources of comfort, ec-
stasy, inspiration, and healing. Music serves as a strong avenue
for releasing or transforming depression, despair, anger, and
jealousy. Singers throughout time have lived with Euterpe as
their primary muse and used music as an essential medium
for inspiration and transformation, as do original songwriters.
Euterpe helps us develop the discipline that registers deep lis-

BRINGING EUTERPE INTO YOUR LIFE

Write your own invocation to bring
Euterpe into your life:

Invocation

O Euterpe, custodian of
songs and music,
Open my throat to the
sonic mystery that dwells there;
stir my voice and expand
its creative capacity.
Allow my songs to burst
forth into the world.
As my sound passes through,
deliver me to the sacred portal
within my nature.

tening and reveals how to give voice to those internal impulses with sounds that are spontaneous, clear, and uncompromising.

Euterpe knows that music has the ability to reveal who we are. The Greek roots of the word "person" (per son) mean "the sound passes through." Euterpe ignites our desire to creatively express ourselves with our voice or through music. Victor Hugo experienced Euterpe's prodding when he wrote: "Music expresses that which cannot be said and on which it is impossible to be silent." The great composers of the world, like Beethoven, Mozart, and Bach, lived and understood Victor Hugo's statement completely. Even Stravinsky is said to have listed himself on his passport as an "inventor of sounds." One of the most comprehensive books written today about the composer's life is *Classical Music: The 50 Greatest Composers and Their 1,000 Greatest Works,* by Phil G. Goulding. Euterpe is the Muse who draws to us the vast resources of composed music, songs, and sounds that most allow our own "sound to pass through" with beauty, majesty, and grace.

MAKE A MUSE COLLAGE OR BULLETIN BOARD FOR EUTERPE

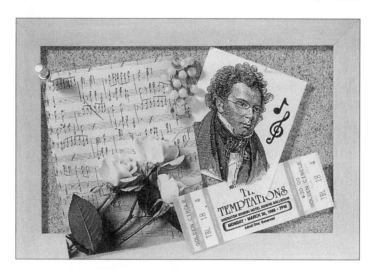

Music "musts." Favorite songs and singers, chants, programs, critics, new and old hits—anything that sparks my connection to sound, song, music . . .

ON A STUDENT BULLETIN BOARD
AT THE JUILLIARD SCHOOL OF MUSIC

REFLECTIONS:

When I hear music, I fear no danger, I am invulnerable. I see no foe.
I am related to the earliest times, And to the latest.

HENRY DAVID THOREAU
Journal (1857)

1. Listen to your favorite music and invite the Muse of Music to visit you. Observe what images or creative ideas occur to you. Jot down the ideas, images, or feelings that you are experiencing in your Muse Journal as you listen to the music you have selected.

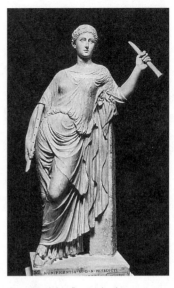

Euterpe with her flute and aulos.

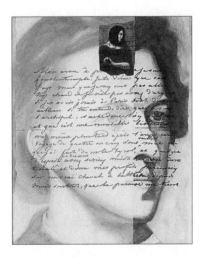 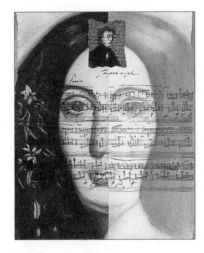

Frederic Chopin and George Sand.

George Sand, who discarded her real name, Aurore Dudevant, for publishing reasons, met Frederic Chopin when he was twenty-six and she was thirty-two. Her literary passion and writing matched his musical genius. During their nine-year romantic liaison, they helped each other enormously with each other's work.

CHARLES HOBSON
Parisian Encounters: Great Loves and
Grand Passions

EUTERPE IN THE WORLD

Physicist Fritjof Capra informs us that the integration of recent insights in physics and the life sciences will require "a conceptual shift from structure to rhythm." Theorists now describe atoms in terms of harmonics; molecules vibrate; each substance "tuned" to a unique pitch; plants and animals undergo cycles of growth and rest; planets fall into resonant orbits; stars oscillate, and galaxies whirl a majestic spiral dance.

RICHARD HEINBERG
Music of the (Hemi) Sphere

Musical creativity comprises one of the mind/brain's most basic forms of intelligence—of equal importance with linguistic, logical, mathematical and interpersonal attitudes.

HOWARD GARDNER
Frames of Mind:
The Theory of Multiple Intelligence

"THE DISQUIETING MUSES"

Mother, you sent me to piano lessons
And praised my arabesques and trills
Although each teacher found my touch
Oddly wooden in spite of scales
And the hours of practicing, my ear
Tone-deaf and yes, unteachable.
I learned, I learned, I learned elsewhere,
From muses unhired by you, dear mother
SYLVIA PLATH

2. Who are your favorite musicians or recording artists? How has your taste in music changed over the last two decades? Create and narrate a current tape of your favorite songs and music.

Music is our myth of the inner life.
SUSANNE LANGER

3. Create a song of your own: a love song, a funny song, a lullaby, a work song; or a spiritual; or write your own words to a favorite melody and sing it every day.

4. For three months, enhance your learning and creative processes by listening to baroque violin concertos. Georgi Lozanov discovered in the 1950s that these concertos provide the ideal context for rapid and comprehensive learning.

Read *Superlearning* by Sheila Ostrander and Lynn Schroeder, and Don Campbell's outstanding work *The Mozart Effect: Tapping the Power of Music to Heal the Body, Strengthen the Mind, and Unlock the Creative Spirit.*

Without music and dance, the triune brain—the human, mammalian, and reptilian centers—doesn't get hooked up, and so the whole person doesn't get developed.

CHARLES KEIL

DIRECTOR OF M.U.S.E., INC.,

BUFFALO, NEW YORK

5. Write a poem, song, or sonnet that honors your favorite kind of music or musician; or collect pictures of your favorite musicians and make a collage or fill a bulletin board with them to inspire you.

"ROMANTICS"

For Johannes Brahms and Clara Schumann

The modern biographers worry
"how far it went," their tender friendship.
They wonder just what it means
when he writes he thinks of her constantly,
his guardian angel, beloved friend.
The modern biographers ask
the rude, irrelevant question
of our age, as if the event
of two bodies meshing together
establishes the degree of love,
forgetting how softly Eros walked
in the nineteenth century, how a hand
held overlong or a gaze anchored
in someone's eyes could unset a heart,
and nuances of address not known
in our egalitarian language
could make the redolent air
tremble and shimmer with the heat
of possibility. Each time I hear
the Intermezzi, sad
and lavish in their tenderness,

I imagine the two of them
sitting in a garden
among late-blooming roses
and dark cascades of leaves,
letting the landscape speak for them,
leaving us nothing to overhear.

LISEL MUELLER

Deep in the human heart, in a rather unconscious way per-
haps, something often whispers and moves, which with
time can resonate in the form of poetry and music.

JOHANNES BRAHMS

FROM A LETTER TO CLARA SCHUMANN

6. Music is a universal source of comfort, healing, and
connection. Create your own musical healing and spir-
itual library. What specific music provides this for you?
Try these resources and activities to help you in this
endeavor:

· Read *What to Listen for in Music,* by Aaron Copland. His
provocative suggestions for listening will bring you to a
deeper appreciation of music. Learn more about music
in *Music, the Brain and Ecstasy: How Music Captures Our Imagi-
nation,* by Robert Jourdain.

· *Music and Meaning,* edited by Jenefer Robinson, is an in-
valuable guide for tracking what music has meaning for
you and why. Invite a friend to share a meaningful con-
cert, opera, or jazz evening.

· Other categories and resources are available on Ama-
zon.com.

· Write an online review and share your thoughts with
other readers and musicians.

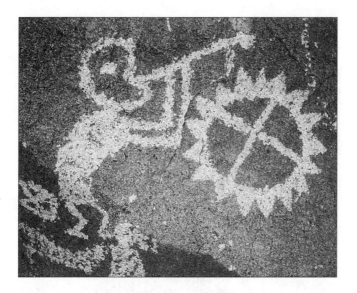

We stay up and sing the sacred songs all night to purify our-
selves so that our dancing and our prayers can do good for
everyone. ALONZO QUAVEHEMA
Rare Glimpse into the Evolving Way of The Hopi

BEVERLY SILLS'S APPLICATION FOR MAJOR
BOWES' AMATEUR HOUR:

I'm 10 years old. I'm studying singing with
Miss Estelle Liebling. I have 22 arias on my
repertoire. I have done 2 pictures with Educa-
tional Films and have appeared at many enter-
tainments, Professional and Amateur

euterpe in the modern world

BEVERLY SILLS, OPERA SINGER

Beverly Sills is known the world over for her operatic talent. For over thirty years, she thrilled audiences with her beautiful voice and stage presence.

Among her recordings, for which she has won both Europe's Edison Award and America's Grammy Award, are eighteen full-length operas. On television she starred in eight operas on PBS and in such specials as "Sills and Burnett at the Met," with Carol Burnett, "Profile in Music," which won an Emmy Award, and "A Conversation with Beverly Sills."

Among her many honors is the Presidential Medal of Freedom, which she received in 1980, when she pulled down the curtain on her singing career at age fifty-one, in order to, in her words, "put my voice to bed so it will go quietly, with pride." Sills has yet another talent, one that is not well known. As National Chair of the March of Dimes Mothers' March on Birth Defects, Sills has helped to raise over $70 million in ten years. Often meeting with parents of children with birth defects and visiting the children in hospitals, Sills has chosen to use her position to raise funds for this organization. Sills's reasons for devoting

herself to the cause of eradicating birth defects stem from her children, Muffy and Peter. At age two, Muffy was diagnosed as suffering from severe hearing loss; several months later, Peter was diagnosed as mentally retarded. After learning these agonizing facts, Sills left the stage to care for her children.

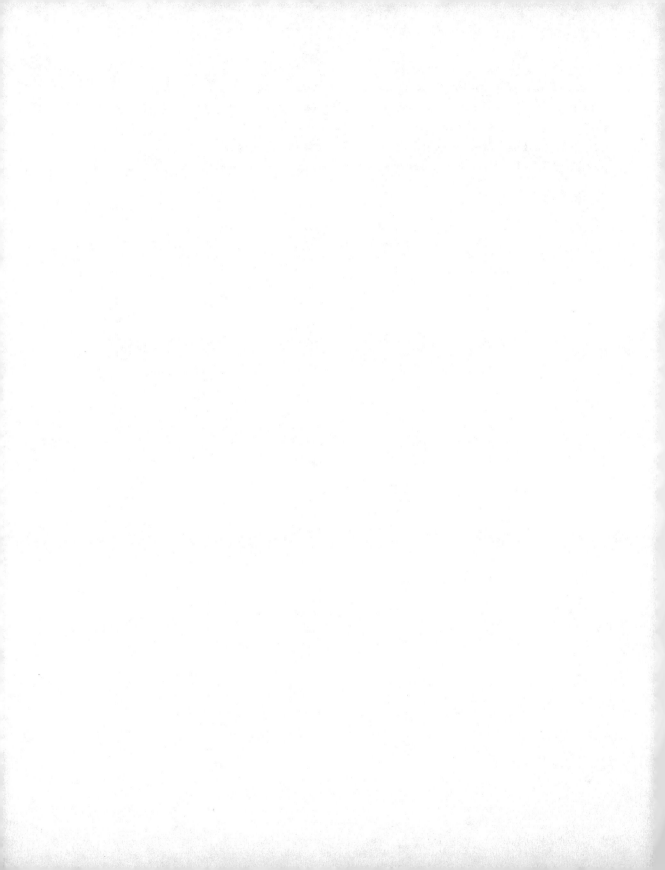

melpomene

muse of tragedy

"Sorrow"

Sorrow like a ceaseless rain
 Beats upon my heart.
People twist and scream in pain,—
Dawn will find them still again;
This has neither wax nor wane,
 Neither stop nor start.

People dress and go to town;
 I sit in my chair.
All my thoughts are slow and brown:
Standing up or sitting down
Little matters, or what gown
 Or what shoes I wear.

EDNA ST. VINCENT MILLAY

Melpomene, the Muse of Tragedy, is the songstress of suffer-
ing, sorrow, and sweet laments—the "goat singer." The
word *tragedy* is believed to be derived from the Greek word
tragoidia, which means "goat-song." The first tragedies were myths
danced and sung by a chorus dressed in goatskins in honor of
Dionysos (the god of wine and of living life fully). For Melpomene,
the tragic life is the life not lived fully.

Melpomene relieves human suffering through authentic and
poignant expressions of grief, disappointment, loss, injustice,
fear, anger, failure, unwise choices, and tragic circumstance.
Melpomene's name comes from the Greek *melpein,* to sing sacred
songs of sorrow. Poet Simone Weil states Melpomene's primary
function when she writes: "Affliction causes everything to be
called into question." Melpomene reminds us that grieving is
necessary to emotional health and that affliction is a natural
process of bringing new life and hope out of loss, painful disap-
pointments, and tragic choices. She is present today in every
hospice situation, homeless shelter, food line, emergency room,
and life-threatening situation. This Muse reveals suffering and
tragic circumstances in order to teach and release the creativity
found in compassion, forgiveness, resourcefulness, and humil-
ity. Writer Isabel Allende reminds us of Melpomene's essential
purpose when she writes: "In terrible moments, in moments of
revolution, of war repression, of illness or death, people react
with incredible strength."

Melpomene champions the premise that humanity is ele-
vated, not belittled, in tragedy. She is the Muse that moves
through someone like actor Christopher Reeve, who, though para-
lyzed from the neck down, demonstrates enormous courage and
creativity in his commitment to change the course of spinal in-
jury research. For Melpomene, virtue and spiritual glory are
vindicated in tragedy. Human beings ultimately gain a spiritual
victory in spite of physical or circumstantial defeat or failure.

Melpomene melts emotional paralysis, numbness, control,
and shock. She requires the expression of emotional honesty and

*Although the world is very full of
suffering, it is also full of the
over-coming of it.*
HELEN KELLER

authentic affect during life's tragic moments and asks us to be responsible and humble in the ownership of our tragic flaws, mistaken choices, and failures. Her motivation and purpose is clearly stated by Plutarch: "To make no mistakes is not in the power of man; but from their errors and mistakes the wise and good learn wisdom for the future." Often Melpomene prompts

BRINGING MELPOMENE INTO YOUR LIFE

Write your own invocation to bring Melpomene into your life:

Invocation

O Melpomene, revealer of suffering,
Give me the courage to face
 the unexpected losses.
Help me forgive my self-betrayals,
 mistaken choices, and failures.
Dissolve my masks!
Free me from stored, unexpressed sorrow.
Release resentment, blame, arrogance, and
 prejudice from my nature;
Deepen my character and restore my faith.
Show me how I can creatively relieve
 or resolve what is tragic and
 unjust in the world.

and urges creative expression during times of depression and deep despair; all dirges, elegies, tragic plays, films, stories, AIDS benefits, funeral tributes, poetic remembrances, the blues, mourning wails, and keening are announcements of her presence.

Melpomene's creative invitation to us is to weave the themes of redemption and to increase our understandings of the tragic consequences behind hubris, misuse of power, greed, unbridled lust, dishonesty, cruelty, and intentional harm. Her aim is to help us condemn the deliberate choices that support evil and our lack of courage regarding our susceptibilities to our own tragic flaws. She dramatically reveals to us today the tragic motivations and results of war, violence, terrorism, hate crimes, famine, plagues, poverty, injustices, and natural disasters—all of which continue to fill our newscasts, newspapers, and television and radio broadcasts.

In Greek mythology, Maenads are unrestrained and sensual spirits who dismember and fracture what is complacent, remote, contrived, apathetic, controlled, and indifferent in anyone's nature. Melpomene was a free-spirited Maenad who gave birth to the Sirens, who tested character and courage with their seductive songs, irresistible sexuality, and haunting soulfulness. Both the Maenads and Sirens tore apart or tested anything weak. They destroyed and exposed ruthless ambition, arrogant will, and narcissistic vanity.

Melpomene helps heartfelt mortals to contend nobly against overwhelming odds and tragic situations, no matter what the outcome. She disarms and shatters the overprotected and closed-hearted. Tragedy is Melpomene's way to initiate us into emotional integrity and the unyielding embrace of authentic suffering, in order to renew courage and character. She requires that we learn from her historical presence at all the world wars. Today Melpomene calls forth our creativity to resolve contemporary tragic scenarios such as Kosovo, famines in Africa, gang violence, situations like Columbine High School, and the threat of nuclear war. Melpomene is the ultimate teacher of service, compassion, forgiveness, and humility that are motivated by unusual creative responses to tragic events and unexpected losses.

"THE WELL OF GRIEF"

Those who will not step beneath
the still surface on the well of grief

turning down through its black water
to the place we cannot breathe

will never know the source from which we drink,
the secret water, cold and clear,

nor find in the darkness glimmering
the small round coins
thrown by those who wished for something else."

DAVID WHYTE
Where Many Rivers Meet

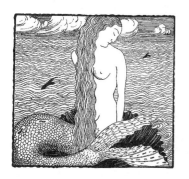

MAKE A MUSE COLLAGE OR BULLETIN BOARD FOR MELPOMENE

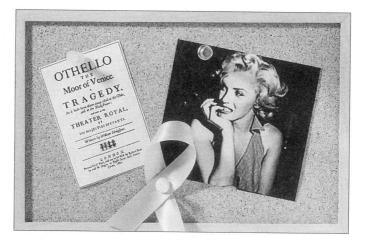

Television sets, movie screens, scripts, news anchors, theme music, commercials, terms like "soundbite" and "spin-doctor" interest me more and more these days. In

these images and ideas I see a way of focusing and exploring the world of my new poems, a world which mirrors what I have been experiencing in psychoanalysis: the disparity between the "official" story and the hidden one, the true one.

LAURIE SHECK

The Poet's Notebook

REFLECTIONS:

Where there is sorrow, there is holy ground.

OSCAR WILDE

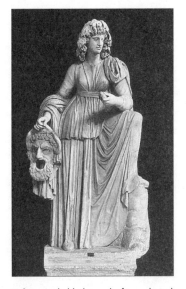

Melpomene holds the mask of tragedy and stone of compassion.

1. Who and what are your sources of comfort and inspiration during times of sorrow, adversity, or affliction? In what ways have you been strengthened by these Melpomene experiences? What "holy ground" are you currently experiencing as a result of some sorrow or adversity?

All sorrows can be borne if you put them into a story or tell a story about them

ISAK DINESEN

2. Create rituals of forgiveness for yourself and others. What forgiveness work do you need to do—for yourself and others? What people or situations have taught you the most about compassion and humility? For example, in a situation that seemed unforgivable, did someone who you admired model something different—like the Dalai Lama extending compassion to the Chinese after being exiled from Tibet?

Declare a Forgiveness Week. Write or send a card of forgiveness. Ask Melpomene to guide you in being as creative as possible during your forgiveness week.

3. What personal tragic circumstances have motivated you to do compassionate service work in your family and com-

FORGIVENESS PRAYER

If I have harmed anyone in
 any way
Either knowingly or
 unknowingly
Through my own confusions
I ask forgiveness.

If anyone has harmed me in
 any way
Either knowingly or
 unknowingly
Through their own confusions
I forgive them.
And if there is a situation I am
 not yet ready to forgive
I forgive myself for that.

For all the ways that I harm
 myself,
Negate, doubt, belittle myself,
Judge or be unkind to myself
Through my own confusions
I forgive myself.

munity? Azim Khamisa and Ples Felix illustrate the creativity that was released as a result of their shared tragedy:

Tariq Khamisa was twenty years old when he was murdered. His killer was Tony Hicks, a fourteen-year-old. In 1995, Tony and three other gang members surrounded Tariq as he was delivering pizzas to help pay for his college education. The gang demanded his money, but Tariq refused. The gang leader then ordered Tony to shoot him. Today, the father of the victim—Azim Khamisa—and the grandfather and guardian of the killer—Ples Felix—have developed an extraordinarily close relationship as they work together to try to stop youth violence. Azim, an international businessman, established the nonprofit Tariq Khamisa Foundation with the purpose of creating safer communities and cultivating in youngsters personal responsibility—guiding them away from gangs. Tony's grandfather, Ples, is a member of the advisory board. Often Azim and Ples stand together at schools and conferences to reveal how youth violence impacted their two families. As they talk it is not unusual to see tears roll down their listeners' faces.

BIOGRAPHY AS PATHOGRAPHY

The era of magisterial biographies . . . has evolved a new subspecies of the genre to which the name "pathography" might usefully be given: . . .

By contrast, pathography typically focuses upon a far smaller canvas, sets its standards much lower. Its motifs are dysfunction and disaster, illnesses and pratfalls, failed marriages and breakdowns and outrageous conduct. Its scenes are sensational, wallowing in squalor and foolishness; its dominant images are physical, and deflat-

ing; its shrill theme is "failed promise," if not outright "tragedy."

<div align="right">

JOYCE CAROL OATES
REVIEW OF *Jean Stafford: A Biography,*
BY DAVID ROBERTS, IN
Where I've Been and Where I'm Going

</div>

4. As a practice of Melpomene's compassion and humility, volunteer for one season to help the homeless; inquire how to help prisoners; create a neighborhood watch; help those in distress because of nature's unexpected floods, fires, or earthquakes; and provide safety and protection for abused children.

As to my heavy sins, I remember one most vividly;
How, one day, walking a forest path along a stream,
I pushed a rock down onto a water snake coiled in the grass.
And what I have met in life was the just punishment
Which reaches, sooner or later, everyone who breaks a taboo.

<div align="right">

CZESLAW MILOSZ
The Witness of Poetry

</div>

5. Read two invaluable life-changing books where Melpomene's influence is expressed throughout: *The Tibetan Book of Living and Dying,* by Sogyal Rinpoche, and *A Year To Live: How To Live This Year As If It Was Your Last,* by Stephen Levine. Both books describe practices in how to live well and die well.

6. What masks do you still wear? What are your temptations or ways of hiding what is incongruent in your nature?

Choose thirty days to practice saying what's so, when it's so, without blame or judgment. For thirty days say only what you mean and do only what you say. Record in your Muse journal

or computer file what you learn while doing this Melpomene practice.

> Behind the masks of these successful lives, there lurks dis-illusionment and terror. One common factor appears repeatedly. Consciously the individuals are being driven to do better and better within the rigid framework they have created for themselves; unconsciously they cannot control their behavior. . . . Willpower can last so long. If that willpower has been maintained at the cost of everything else in the personality, then nothing gapes raw. When in the evening, it's time to come back to oneself, the mask and the inner Being do not communicate.
>
> MARION WOODMAN
> *Addiction to Perfection: The Still Unravished Bride*

> "Misprision. I first learned the word in a Shakespeare sonnet I memorized in school. An Elizabethan word, rarely used today. It means 'mistakenness,' 'to have taken something wrong'—misapprehension or 'misperception' we might say today." She goes on to relate misprision to events in the Soviet Union and the Gulf War, then applies the word to power, meaning, "To have taken something wrongly, to have mis-taken, to have ill-used what was taken, what ought not to have been taken, to misrepresent, misapply, divert to other means what ought to have its own rhythm and purpose. Misprise: to value wrongly. To value wrongly—the worst misconduct by a public official . . ." The word itself has intimations of "prison," "pry(pries)," and prize. All seem appropriate to what Adrienne says about the word.
>
> CYNTHIA MACDONALD, POET
> IN *What Is Found There: Notebooks*
> *on Poetry and Politics,*
> BY ADRIENNE RICH

Melpomene in the Modern World

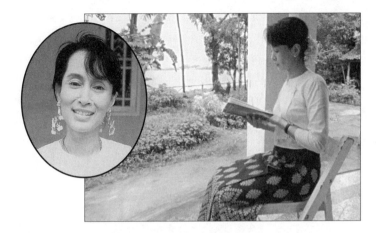

AUNG SAN SUU KYI, BURMESE POLITICAL LEADER

At the ceremony for Aung San Suu Kyi for the Nobel Peace Prize in December 1991, she was still being held in detention by the military dictatorship in Myanmar (Burma) and could only be represented by her two sons. Professor Francis Sejersted, chairman of the committee, declared, "Her absence fills us with fear and anxiety." But he felt we could also have confidence and hope. He went on to sum up the meaning of her prize:

> In the good fight for peace and reconciliation, we are dependent on persons who set examples, persons who can symbolize what we are seeking and mobilize the best in us. Aung San Suu Kyi is just such a person. She unites deep commitment and tenacity with a vision in which the end and the means form a single unit. Its most important elements are: democracy, respect for human rights, reconciliation between groups, non-violence, and personal and collective discipline.

The sources of her inspiration, Sejersted explained, were Mahatma Gandhi, about whom she had learned when her

mother was ambassador to India, and her father, Aung San, the leader in Burma's struggle for liberation. She was only two when he was assassinated, but she had made his life a center of her studies. From Gandhi she drew her commitment to nonviolence, from her father the understanding that leadership was a duty and that one can only lead in humility and with the confidence and respect of the people to be led. Both were examples for her of independence and modesty, and Aung San represented what she called "a profound simplicity."

polyhymnia

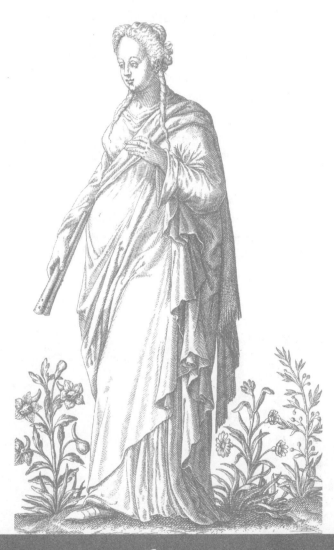

muse of oratory,
sacred hymns, and poetry

"Merger Poem: A Vision for the Future"

And then all that has divided us will merge
And then compassion will be wedded to power
And then softness will come to a world
 that is harsh and unkind
And then both men and women will be gentle
And then both women and men will be strong
And then no person
 will be subject to another's will
And then all will be rich and free and varied
And then the greed of some
 will give way to the needs of many
And then all will share equally
 in the earth's abundance
And then all will care
 for the sick and the weak and the old
And then all will cherish life's creatures
And then all will live
 in the harmony with each other and the
 earth.
And then everywhere
 will be called Eden once again.

JUDY CHICAGO, ARTIST

Polyhymnia is the Muse who honors the subtlety, refinement, and hidden mystery found in daily living. She directs us to the places of silence, contemplation, and reflection. Her name comes from the Greek poly (many), and hymnos (hymn), or from mnastai (to remember)—she who is rich with hymns, oral language, and sacred poetry.

Polyhymnia reveals how we can see the sacred in the ordinary and how to creatively express in eloquent and inspired speech the praise and pleasure of touching the sacred. She is the inspiratrix, the one who inspires and evokes wonder, awe, and curiosity in the mystery, the sacred, and the known and unknown worlds. Polyhymnia inspired May Sarton's book *Journal of a Solitude* and served as inspiratrix and Muse to Fanny Crosby, a blind poet who wrote over nine thousand hymns during her life (1820–1915) and has the distinction of being America's most known hymn writer.

Polyhymnia is responsible for igniting all poets who touch the numinous, mystical, and inspirational realms and who speak and create lines of such exquisite beauty that those who read or hear the lines and images are deeply moved. Some examples of those inspired poetic lines are:

> The golden turtle on the sands shows me where he conducts the chorus of the Muses and where the will of God augustly triumphs. RUBÉN DARÍO

> Touched by God's Eye, the feather turns into the angel Liberty. VICTOR HUGO

> Truly, I dwell in the throat of a god. SAINT-JOHN PERSE

> *I was thinking:*
> *So, this is how you swim inward*

Creativity involves a leap of faith. When writers move onto a blank page, they need a certain amount of nerve or faith. When actors audition or singers get up to sing, they must have courage, and courage takes faith. I don't believe there is any difference between spiritual energy and creative energy.

JULIA CAMERON
AUTHOR OF *The Artist's Way*

So this is how you flow outward
So this is how you pray.
MARY OLIVER

Sometimes the day opens out like an alley of green lights
up ahead. LIZ ROSENBERG

Be Thou my vision, O Lord of my heart.
MARY BYRNE, 1880–1931
TRANSLATED FROM ANCIENT IRISH

Polyhymnia's presence is found in all the liturgical music of the
world—Gregorian chants, gospel music, church hymns, Tibetan
overtone chanting, initiatory rites, and spirituals—all ways the
human spirit praises and rejoices in the sacred and mysterious.
She often is present in the initiation of rituals, ceremony, prayer,
and sacred texts. The words *temple* and *contemplate* are derived
from the Greek word meaning "to cut"—to indicate a separation
between the sacred and the secular. Polyhymnia is committed to
bridging both the sacred and ordinary. She sparks a link between
silence, our thoughts, and the compelling communication of
what touches us deeply. Poet Carolyn Forché recognizes Poly-
hymnia's purpose when she writes, "Poetry allows the human
soul to speak."

Polyhymnia's relationship to silence and reflection stirs
within us a desire to silently express what was found in contem-
plation either through pantomime and mime, and then through
hymn, ritual, or poetry. Polyhymnia reminds us that the most
moving moments of our lives sometimes find us without words.
Her presence is seen through the exquisite gifts of Marcel
Marceau, this century's greatest mime, who with his artful silent
movements ignites the imagination to see subtle internal feel-
ings and external possibilities. Pantomime and sacred ceremony
were often ways to express the learnings from the silent world in
a reverential way before speaking and singing. Polyhymnia re-
minds us to trust the sacred silence as a way to listen for the guid-

ance to speak the words that are most aligned with our interior experience.

From this connection to the sacred, Polyhymnia ignites within us the art of eloquent, clear, and inspirational speech known as oratory. She inspires the use of language and speech

BRINGING POLYHYMNIA INTO YOUR LIFE

Write your own invocation to bring Polyhymnia into your life:

Invocation

O Polyhymnia, unlimited resource of
 creative communication,
Grant me the ability to deeply listen; and
 to speak
 what has heart and meaning for me.
Let me speak the words that match the
 integrity of my Soul.
Help me speak in ways
 that unify and clarify.
Give me the courage to voice
 what is just, true, and memorable.
May my words uplift the human spirit
 and praise what the sacred has given us.
Guide me today in all my conversations.

that are lucid, beautiful, ingenious, and imaginative. Speakers like Martin Luther King, Eleanor Roosevelt, Wilma Mankiller, and Mahatma Gandhi were all models of Polyhymnia's deep convictions, faith, and right speech. You can see Polyhymnia's oratory influence today on radio and television in special interviews, debates, public speaking; she inspires motivational speakers, activists, and modern-day talk show hosts.

Human speech conveys more than words, just as music conveys more than sounds. The ability to ignite the imagination through speech and to inspire the sense of being uplifted and touched are Polyhymnia's greatest gifts. All the great speeches, mimes, and talk shows have had this Muse at their heart.

- Nehru speaks to mourning millions a few hours after the murder of Gandhi (January 30, 1948)

 For the light that shone in this country was no ordinary light.

- Lincoln argues that a house divided against itself cannot stand (June 16, 1858)

 I believe this government cannot endure permanently half slave and half free.

- Maya Angelou, poem for President Clinton's inauguration, "On the Pulse of the Morning" (January 1993)

 History, despite its wretching pain, cannot be unlived, but if faced with courage, need not be lived again.

MAKE A MUSE COLLAGE OR BULLETIN BOARD FOR POLYHYMNIA

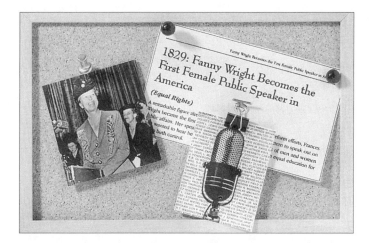

Add the silent learnings to your refrigerator door, calen-
dar, or office bulletin board—the mystery and answers
appear in soft and subtle ways. ANONYMOUS

REFLECTIONS:

> *If truth were self–evident, eloquence would not be necessary.*
> CICERO

1. Spend time in silence every day. Discover what you
 learn from contemplation, prayer, meditation, or soli-
 tude in nature. Enter in your Muse Journal the insights
 or creative breakthroughs that arise as a result of spend-
 ing silent time with yourself.

 Listen to presences inside poems.
 Let them take you where they will.
 Follow those private hints,
 And never leave the premises.

 RUMI

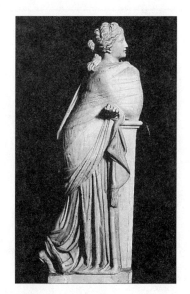

Polyhymnia at her podium as she delivers
her speech.

*I do believe it is possible to
create, even without ever writing
a word or painting a picture, by
simply molding one's inner life.
And that too is a deed.*

ETTY HILLESUM

The Chinese character for poetry combines
word and *temple*.

"PRAYER TO MY MUSE"

The door is closing

*where ghosts hide,
where gods hide,
where even I hide.*

*I'm none too sorry,
longing to be back
coiled in my wombworld,*

*too smug and small, I know,
no wider than my bed
where no one sleeps but me.*

*Still, crack the door a little,
stepmother muse to show
a night light burning.*

VASSAR MILLER

2. If you were to write your own spiritual autobiography,
 what would be the ten most important spiritual experi-
 ences you would want to be in it? In your Muse Journal,
 list your ten most significant spiritual experiences.
 What have they awakened within you?

• Read *Essential Spirituality*, by Roger Walsh.

• Create a drawing or collage that addresses your rela-
 tionship to faith or lack of faith. What does "spiritual-
 ity" mean to you? How has your relationship to
 spirituality or faith changed over the years?

3. Create a repertoire for prayer. Write a prayer, poem, or
 chant honoring your connection to the sacred. Create a
 sacred hymn to honor one of your ancestors.

For me, poetry's a safe place—always, a refuge, and it has
been since I took it up in the eighth grade, so it was natural
for me to write about these things that were going on in my
own soul. JANE KENYON

4. Memorize or read an inspirational or great speech from
 history or modern time. A good resource to read for
 speeches is *In Your Own Words: Extraordinary Speeches of the
 American Century,* edited by Robert Torricelli and Andrew
 Carroll.

Samples of Great Speeches

- Queen Elizabeth rallies her army during the Armada
 peril (July 19, 1588)

 I have a heart of a king.

- Martin Luther King speaks to a unique audience
 (August 28, 1963)

 I have a dream . . .

- Eleanor Roosevelt addresses the United Nations with
 her International Bill of Human Rights (December 10,
 1948)

 The unalienable rights of all members of the human
 family is the foundation of freedom, justice, and
 peace in the world.

5. What public speaking have you enjoyed or found chal-
 lenging?

- Join Toastmasters to become more comfortable with
 public speaking.

• Ask Polyhymnia to help you write your own speech about something very important to you; or make up a speech extolling your current creative enterprise.

6. Take a presentation skills course or videotape your speech and learn from what you see works or could be improved. Invite a circle of friends over to practice a presentation you may need to make at work.

Hear me, you hearers, and learn of my words, you who know me.
I am the hearing that is attainable to everything;
I am the speech that cannot be grasped.
I am the name of the sound and the sound of the Name . . .
For I am the one who alone exists, and I have no one who will
 judge me.

"THE THUNDER, PERFECT MIND," IN
The Nag Hammadi Library

"TURNING"

turning into my own
turning on in
to my own self
at last
turning out of the
white cage, turning out of the
lady cage
turning at last
on a stem like black fruit
in my own season
at last

LUCILLE CLIFTON

polyhmnia in the modern world

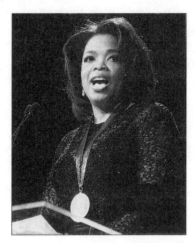

OPRAH WINFREY

At age nineteen, Oprah Winfrey started her first broadcasting job—as a reporter at radio station WVOL in Nashville—and enrolled at Tennessee State University to study speech and performing arts. In her sophomore year, 1972, she switched media and became the first African American anchor at Nashville's WTVF-TV. She moved to Baltimore in 1976, and after two years working as a reporter and coanchor at WJZ-TV, she was hired to host the station's chat show, *People Are Talking.* In 1984, after eight years at WJZ, she accepted a job as host of *A. M. Chicago,* a show scheduled opposite Phil Donahue's top-rated national morning show.

During this time, she was offered a movie assignment to play Sofia in Steven Spielberg's 1985 cinematic adaptation of Alice Walker's novel *The Color Purple.* For her performance, she won an Oscar nomination for best supporting actress. In 1986, she launched the *Oprah Winfrey Show* as a nationally syndicated program. She has focused on uplifting and meaningful subjects and has developed a section at the end of each program called "Remembering the Spirit." The result: Oprah Winfrey is the third woman in history—after Mary Pickford and Lucille Ball—to own

a major studio ("Harpo" Productions—Oprah spelled back-
ward). Oprah shares her good fortune with several charities and
educational institutions and is instrumental in supporting chil-
dren's rights and creative projects that make a difference in the
world.

terpsichore

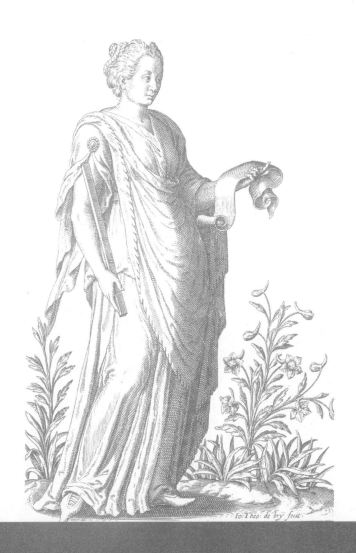

muse of dance

In this hundred years, the five shaping artists are, I
believe, Igor Stravinsky, Béla Bartók, Frank Lloyd
Wright, Pablo Picasso, and Martha Graham. As far as
dancing and theater are concerned, this is her century.
And of all five giants, Graham made the greatest
change in her art—in the idiom, in the technique, in the
content, and in the point of view—greater, finally, than
any other single artist who comes to mind.It is
probably the greatest addition to dance vocabulary
made in this century, comparable to the rules of
perspective in painting or the use of the thumb in
keyboard playing. Martha is the supreme force.
Her compositions are masterful. Martha is the one.

AGNES DE MILLE, DANCER AND CHOREOGRAPHER

Terpsichore, the Muse of Dance, awakens the recognition that the body is a beautiful instrument for movement and expression. Her name means "she who loves to dance," and her favorite dancing instruments are the lyre, an ancient instrument that inspired movement and creative rhythms, and her large triangle was used to set the rhythm for dance steps. The lyre was the most important stringed instrument used in ancient Greece and Rome. Hermes was said to have invented the lyre by catching a large tortoise, cleaning out the shell, stretching cowhide over the opening to produce a sound chest. For the vertical frame, he used gracefully curving antelope horns to which he attached a yoke of wood. Sheep gut was used for the strings. Because of the striking sound produced from the tortoise shell, ancient writers, particularly poets, referred to the lyre as the "tortoise."

For Terpsichore, dance serves as a somatic response to music or silence and provides a vehicle for recreation, self-expression, and the release of surplus energy. She ensures that dance is found everywhere in the world as a medium of affirmation and a way for people to create shared meaning, beauty, and recreation together. Dancer Martha Graham shared the true meaning of Terpsichore's function when she said: "We look at the dance to impart the sensation of living in affirmation of life, to energize . . . the mystery, the humor, the variety and the wonder of life. This is the function of dance—especially the American Dance."

Terpsichore encourages us to use the body as an authentic vehicle to express both internal and external experiences. Dancers like Mikhail Baryshnikov, Twyla Tharp, Gabrielle Roth, and Bill T. Jones express Terpsichore's demand for congruency. Terpsichore knows that without movement we begin to degenerate, lose our vitality, and close down our possibilities for full creative expression. Gymnastics, sports, and ice-skating demonstrate Terpsichore's desire to show forth the unusual and natural capacities of the human body. The body is a storehouse of gifts, talents, and resources and often has an unrealized capacity for excellence and beauty. It reminds us of our mortality and com-

There are three kinds of dancers: those for whom dancing is physical exercise, those who dance to express emotion, and those who hand over their bodies to the inspiration of the "soul."

ISADORA DUNCAN

municates its basic needs for food, water, sleep, sex, and assistance needed during illness. Terpsichore ignites our desire to care for and attend to the body in healthy nonnarcissistic ways, to use it as an instrument of expression for our life dreams, and for communication, athletic skill, and enjoyment.

This muse brings grace and beauty to the dances of the world. Argentinean dancer Edward Villella honored Terpsichore when he said: " I am only half alive when I am not dancing. I am fully alive only when I dance. When I'm dancing at my best, I feel exposed, and confident in that nakedness. I feel that life is wonderful, that everything is possible." Terpsichore's presence is also found today in the ritualized beauty of Cirque du Soleil, the martial arts, hatha yoga, Tai Chi, and Kabuki theater and dance. An ancient Japanese legend says that Okumi was a shrine maiden who brought her unique and lively dance to the dry riverbeds of the ancient capital of Kyoto in the seventeenth century, and that over the next three hundred years this dance developed into Kabuki, a sophisticated, highly stylized form of dance and theatre.

In East Indian tantric practices, Terpsichore is expressed in the way the body is prepared for the sacramental expression of sexuality in order to enhance spiritual and physical union. Her desire is to use the body as an aesthetic expression, as an art form that exudes the sense of passion and the sacred.

Terpsichore teaches us that the body is individually and socially imprinted by memories, pleasures, and pain. Through dance, rhythm, and movement, she shows us that the body is not only a miracle of flesh, bones, nerves, and organs but also a mysterious system of energy, vitality, stamina, and euphoria. No matter how we feel about dance or our bodies, Terpsichore nudges us to remember that movement connected to meaningful and authentic expression unravels the crystallized mental and emotional patterns in our bodies. She reminds us that using the body creatively not only reconciles us to the physical world but also changes our state of mind and enhances our well-being. Her presence motivates sports visualization and sports psychology to strengthen the link between the mind and body.

When we are motivated to move, and especially to dance, we know that we are in Terpsichore's presence. She enables people to move beyond their habitual experience: to lighten inhibitions; to awaken new potential for life; to unite the body, mind, and heart; and to enhance communication to simulate and to release emotions. Terpsichore knows that any kind of dance transforms the dancer into something other than themselves, giving them the opportunity to transcend limiting self-concepts and enter the natural state of free-spirited vitality and exuberant beauty that is inherent within the human spirit.

Terpsichore makes herself known to us in all the forms of movement, sports, dance, and exercise in our life. She motivates us to attend to the body's health and well-being through the many exercises and movements found in the dances and sports of the world.

Remember, Ginger Rogers did everything Fred Astaire did, but she did it backwards and in high heels.

FAITH WHITTLESEY

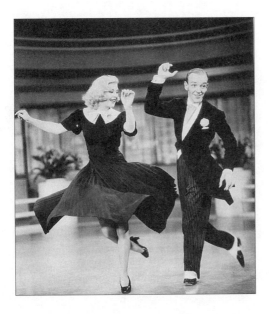

BRINGING TERPSICHORE INTO YOUR LIFE

Write your own invocation to bring
Terpsichore into your life:

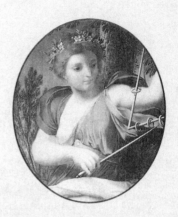

Invocation

O Terpsichore, appreciator of the body
 as a miraculous instrument,
Show me the way to care for my body.
Help me access the natural grace, flexibility,
 and vitality that reside in my body.
Free the artificial constructions
 I have imposed on my body.
Guide me to the ways my body
 would love to move and dance.
Let me listen deeply to my body wisdom.
May I express fully in my body who I am.

MAKE A MUSE COLLAGE OR BULLETIN BOARD FOR TERPSICHORE

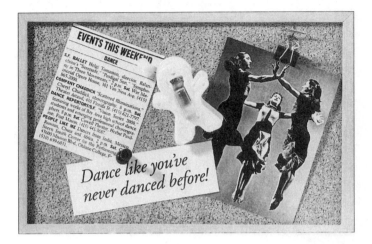

Reasoning about God and other ethics came late. Primitive man sought his answers in myth and ritual; he danced out his faith before he thought it out. HUSTON SMITH,

Great Religions of the Earth

REFLECTIONS:

All my dances have been conceived by seeing female muses dancing in my head.

GEORGE BALANCHINE, CHOREOGRAPHER

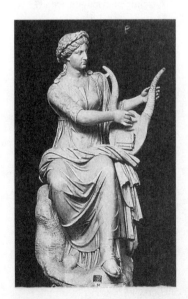

1. Listen to music that you like moving to and invite the Muse of Dance to join you. Ask Terpsichore to show you what your body desires in the way of movement, flexibility, and stamina. How can you best care for your body now? Take an action each day to support your body's well-being through some form of exercise or movement.

2. Review the five rhythms listed in the Dance Resource box. Practice all five rhythms until you feel comfortable with each one.

3. Dance or exercise every day. Each of the following dances provides good exercise and has a unique rhythm.

Terpsichore strums the lyre to prepare for her dance.

Dance Resources

Professional dancer Gabrielle Roth in her book *Maps to Ecstasy* teaches the five rhythms that are elemental when any human being explores dance:

- The flowing rhythm is a teacher of fluidity and grace.
- The rhythm of chaos is an announcement of creativity seeking a form.
- The staccato rhythm is the teacher of definition and refinement.
- The lyrical rhythm is the teacher of synthesis and integration.
- The rhythm of stillness is the teacher of contentment and peace.

When we are comfortable with all five rhythms, the separation between inner and outer experience is closed. Folk wisdom from East Africa describes the essence of this unity by the saying "One leg cannot dance alone."

Go to www.voiceofdance.org for the most complete information on National Dance Week. Explore the places in your community where dance is learned and created during National Dance Week.

These are a small sample of dances originated from other cultures. Choose the one that you have explored the least and practice it for a week to increase your coordination.

The polka was originally a Czech folk dance. It was invented by Anna Slezek in Labska Tynice in 1834 one Sunday for her amusement.

The six Latin American dances the samba, rumba, paso doble, cha-cha, jive, and tango are danced the world over, both socially and in dance sport competitions.

The Charleston originated in the Cape Verde Islands and was a round dance done by dock workers in the port of Charleston. It became popular after its inclusion in the 1923 Ziegfeld Follies stage show *Running Wild.*

Are there others you would like to try?

4. Practice moving like one of the dancers you have admired in history or in modern times. Write a poem or short two-page description of your favorite dance or dancer; or sign up for dance classes. Some examples of well-known dancers are:

Isadora Duncan, Josephine Baker, Carmen De Lavallade, Lew Christensen, Ruth St. Denis, Martha Graham, Tina Turner, Bill T. Jones, Gregory Hines, Anna Halprin, Mikhail Baryshnikov, Merce Cunningham, and Twyla Tharp.

Learn more about dance and dancers by going to the web page www.dancer.com/dance-links/.

5. Choose one night a week to go dancing, or invite friends to watch live dance or classic dance films, or sign up for dance classes. In addition, many video catalogs have dance film specialties; some films are devoted only to classic dance film excerpts. For a

special creative treat, order Peter Buffett's video *Spirit: A Journey in Dance, Drums and Song* from amazon.com. See it with friends and discuss what you learned about the creativity used to integrate ancient and modern forms of dance.

"MONEYLIGHT"

Last night I danced alone
in my darkened living room.
Usually when I do this
I am rock'n rolling, in a way I'd be
embarrassed to do
in public. I dance alone
because that kind of dancing doesn't
require a partner, anyway. But
last night, when I danced, I
held my hands as if they were on the
shoulder and holding the hand
of a man, a partner.

DIANE WAKOSKI

Dancer Celia Cruz is considered to be the Queen of Salsa.

"CELEBRATION OF THE BODY"

I love this body of mine that has lived a life,
its amphora contour soft as water,
my hair gushing out of my skull,
my face a glass goblet on its delicate stem
rising with grace from shoulders and collarbone.

I love my back studded with ancient stars,
the bright mounds of my breasts,
fountains of milk, our species' first food,
my protruding ribcage, my yielding waist,
my belly's fullness and warmth.

I love the lunar curve of my hips
shaped by various gestations,
the great curling wave of my buttocks,
my legs and feet, on which the temple stands.

I love my bunch of dark petals and secret fur
keeper of heaven's mysterious gate,
to the damp hollow from which blood flows
and the water of life.

This body of mine that can hurt and get ill,
that oozes, coughs, sweats,
secretes humours, faeces, saliva,
grows tired, old and worn out.

Living body, one solid link to secure
the unending chain of bodies.
I love this body made of pure earth,
seed, root, sap, flower and fruit.

DAISY ZAMORA
TRANSLATED BY DINAH LIVINGSTON

terpsichore in the modern world

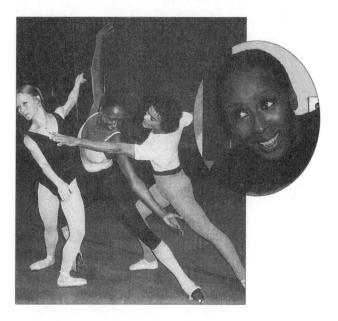

JUDITH JAMISON

After she was discovered by Agnes de Mille at a master class in 1964, Judith Jamison made her New York debut in de Mille's ballet *The Four Marys* with the American Ballet Theater. She became a member of the Alvin Ailey American Dance Theater in 1965. Ailey, recognizing her extraordinary talent and captivating stage presence, created some of his most enduring roles for Judith—most notably in Cry; in 1988 she was the youngest recipient ever of the Dance USA Award.

Today, Judith Jamison presides as Artistic Director of the Alvin Ailey American Dance Theater and the Ailey School, the official school of the company. She has also furthered Alvin Ailey's desire for community outreach by expanding Ailey Camps into Philadelphia and Boston. She is responsible for bringing dance to the community and making children understand their role in maintaining the arts in the forefront of our culture. She has also been a guiding force behind a new B.F.A. program

formed by a collaboration between the Ailey School and Ford-
ham University. This program offers students a unique oppor-
tunity to receive both superb dance training and a superior
liberal arts education.

A recipient of many honorary doctorate degrees, Jamison's
most recent honorary degree was awarded to her by Harvard
University in 1999.

thalia

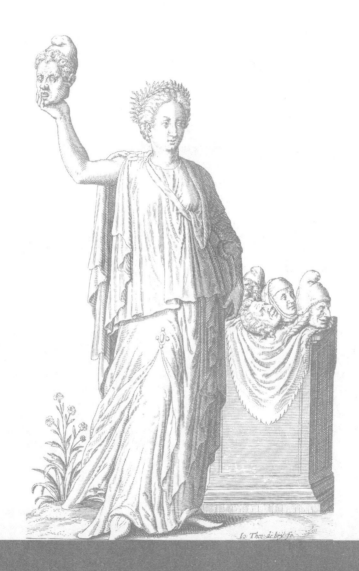

muse of comedy

I personally believe that each and every one of us was

put here for a purpose, and that's to build and

not to destroy. And if by chance some day you're not

feeling well, you should remember some silly little thing

that I've said or done, and it brings back a smile to

your face or a chuckle to your heart, then my purpose

as the clown has been fulfilled.

RED SKELTON AT EIGHTY-FOUR YEARS OLD

The word "comedy" comes from the Greek word *Komos*, which means to revel with others; or to be in a procession of revelers, singing, laughing, dancing, and bantering with onlookers. Thalia, the Muse of Comedy, is the bringer of celebration and festivities through the spirit of joy, laughter, and play. Her name comes from the Greek *thallen* (to bloom). Comedian Steve Martin reminded us of Thalia's healing power when he marveled at the vintage clips of Mike Nichols and Elaine May laughing so hard they couldn't do their routines: "That's why comedians live so long—that kind of happiness."

Thalia points the way to the joyful expression and unfolding of our gifts and talents. Shakespeare revealed the gift of vision that is often found in comedy when he wrote: "Jesters do oft prove prophets." Thalia is committed to infusing us with insight and unexpected vision so we can create the experience of delight and happiness in our lives by developing and enhancing our sense of humor and our instinct for play. She announces her presence when we laugh, play, celebrate, and create good mischief together. Her presence comes into our life through the great comedians—Charlie Chaplin, Imogene Coca, Sid Caesar, the Marx Brothers, Mae West, Bill Cosby, Fanny Brice, Minnie Pearl, Carol Burnett, Robin Williams, Mary Tyler Moore, Erma Bombeck, Will Rogers, Lucille Ball, and Bob Hope, to name a few. Today the American Comedy Institute in New York says that the best comedy training does three things. One: it helps you find your own unique comic voice. Two: it teaches how to communicate that unique comedy skillfully, fearlessly, and entertainingly to the largest possible audience. Three: it instills love and respect for comedy. These comedic skills are always present at the annual U. S. Comedy Arts Festival in Aspen, Colorado, where comedians gather to learn from each other's experience and repertoires.

Thalia relentlessly prods us to consider other options when we are faced with polarities, oppositions, and paradoxes. Hers is

The earth laughs in flowers.
E. E. CUMMINGS

always the unexpected solution that produces the return to wonder, awe, and delight. She models the sustained curiosity and flexibility that comes from a well-developed sense of humor. Her mission is to unify, include, reconcile, surprise, and delight. She brings comfort and emotional release where there is tension, misunderstanding, and hardship. When we are amused, we have been touched by Thalia, who reassures us that our concerns are temporary or can be handled with more humor and

BRINGING THALIA INTO YOUR LIFE

Write your own invocation to bring
Thalia into your life:

Invocation

O Thalia, bringer of joy, laughter, and humor,
Infuse the spirit of celebration, amusement,
 and recreation into my life.
Grant me the ability to expand my
 capacity for creative play.
Open my eyes and heart to laughter
 so that I may be renewed.
Increase the healing power of
happiness in my nature.
 May joy and happiness fill the world.

curiosity. This has been the major function of cartoonists Charles Schultz, Patricia McDonnell, Garry Trudeau, Cathy Guisewite, and Scott Adams, who live with Thalia daily.

Through the forms of comedy, which include joking, clowning, playing, and jesting, Thalia opens us to new possibilities not yet considered and pokes fun where we are taking ourselves too seriously. Today contemporary comedians such as Margaret Cho, Raymond Ramon, Andrew Lacapa, Chris Rock, and Whoopie Goldberg bring humor and increased awareness of the rich humor of diversity that is inspired through Asian, Latin, Native American Indian, and African cultural roots. Thalia reflects the truth and fairness in all situations in humorous and direct ways that awaken recognition and self-discovery without humiliation. Her desire is to use comedy for purposes of healing, awakening, comforting, and regenerating human experiences and life circumstances. Her purpose was not to use humor in harmful or diminishing ways. Thalia's presence was the heart of Charlie Chaplin's philosophy: "We all want to live by each other's happiness, not by each other's misery. We don't want to hate and despise one another. In this world, there is room for everyone and the earth is rich and can provide for everyone."

Thalia compels us to celebrate the blessings, opportunities, and resources that are abundantly available to us. She reminds us that happiness is not someone else's responsibility but is a golden key waiting to be remembered that resides within each of us. She is always present in family laughter, group playfulness, and celebratory gatherings. Thalia lives in the heart of all comedians and in humorous stories that restore hope and heal the human spirit. She shepherds the good, true, and beautiful within us and reminds us that the gods are tickling us when we find ourselves in states of joy, laughter, and happiness.

Laughter and Comedy Open the Door for Creativity and Healing

Facts About Laughter, by Robert R. Provine

- Laughter typically appears in human babies around three-and-a-half to four months of age, but we know little about the details of the developmental process. Perhaps smiling is preparation for the experience of laughter.

- In the absence of stimulating media (TV, radio, or books), people are about thirty times more likely to laugh when they are in a social situation than when they are alone.

- Most adult human laughter occurs during conversation, in mutual playfulness, in groups that have feeling and positive emotional tone—these mark the social settings of most naturally occurring laughter.

THE FERTILE IMAGINATION

© 1999 Richard Stine

Laughter is the shortest distance between two people.

VICTOR BORGE

MAKE A MUSE COLLAGE OR BULLETIN BOARD FOR THALIA

Laughter can be more satisfying than honor; more precious than money; more heart-cleansing than prayer.

HARRIET ROCHLIN

REFLECTIONS:

He deserves Paradise who makes his companions laugh.
THE KORAN

1. Discover what or who makes you laugh—this is your doorway to creativity and healing. Thalia knows that people who have a good sense of humor are also creative people. In your Muse Journal, write about the funniest thing that has happened to you or a family member, or create a tribute to your favorite comedians.

From joy springs all creation
By it is sustained
Towards joy it proceeds
And to joy it returns
MUNDAKA UPANISHAD
TRANSLATED BY A. MOOKERJEE

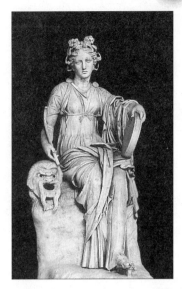

Thalia, with her mask of comedy, prepares herself for theater.

2. Invite a group of your friends or family to get together for a comedy night. Ask people to bring five favorite jokes, funny stories, or comedy routines. Hold a dialogue afterward sharing what everyone learned from the experience. Who were the humor producers, and who were the laughers? Which one are you most predominantly?

Question put to Robin Williams by *Neoplanet,* a website magazine:

NEOPLANET: Are we the first to suggest that your mind works like the Net—hyperlinking to the most unexpected places?

ROBIN WILLIAMS: It's my reality. It's the way I do comedy. It's hypercomedy, which is very much like hypertext. I make a reference to one thing and it spins me off in a completely new direction; something within that reference will draw you to another thing. When I first saw hypertext, I said, "My God! This is the way I write,

or at least the way I perform, at its best." It's all free association.

3. Create your own Book of Jokes or add a joke section in your Muse Journal or computer file and fill it with your favorite cartoons and the funniest things you've ever heard. Write one of your own jokes or invite a friend to go with you to a comedy club to gather new jokes.

Time spent laughing is time spent with the Gods.

JAPANESE PROVERB

4. Draw two of your own cartoons, or try to rewrite the captions to a cartoon from the newspaper, magazine, or this cartoon:

"Hold on. I'm going to call for backup."

For example, "Don't worry, there are many possibilities that you haven't considered that are hovercrafting."

I. _____

2. _____

5. For one week, track what or who makes you laugh. Add
 the experiences to your joke book or Muse Journal (in-
 clude limericks, favorite comedians, jokes, cartoons,
 and short conversations that made you laugh). What did
 you learn or discover about your sense of humor?

See, the human mind is kind of like . . .

a piñata. When it breaks open,
there's a lot of surprises inside. Once you get the piñata
perspective, you see that losing your mind
can be a peak experience.

I was not always a bag lady, you know.
I used to be a designer and creative consultant. For big
companies!
Who do you think thought up the color scheme
for Howard Johnson's?
At the time, nobody was using
orange and aqua
in the same room together.
With fried clams.

Laugh tracks:
I gave TV sitcoms the idea for canned laughter.
I got the idea, one day I heard voices
and no one was there.

Who do you think had the idea to package panty hose
in a plastic goose egg?

JANE WAGNER
The Search for Signs of Intelligent Life in the Universe,
PERFORMED BY LILY TOMLIN

Tickled pink, the elephant
giggled
 at its new color;
Hoping it would stay;
 and that the gray would
go away.

EIGHT-YEAR-OLD GIRL
BOISE, IDAHO

Thalia in the Modern World

Lily Tomlin

This Tony and Emmy Award–winning actress is known for her brilliant and funny characters on television, stage, and film. Her telephone operator character, Ernestine, and her childlike Edith Ann character were both created on the television show *Laugh-In* (1960s) and have become part of the national consciousness. Her film roles range from *Nashville* (1975) to *Tea with Mussolini* (1999).

Lily Tomlin was born Mary Jean Tomlin on September 1, 1939, in Detroit, Michigan. In college she was a premedical student (she was great in math and science). In her second year of college she auditioned for her first play, *The Madwomen of Chaillot* and she also appeared in Moliere's comedy *The School for Wives* as a maid. After her college experience she moved to New York in 1960.

Some of Lily's numerous awards include five Emmys, two Tonys, and a Grammy award (for best comedy album) from the National Academy of Recording Arts and Sciences for her 1971 album called *This Is a Recording*, which also went gold. *The Search for Signs of Intelligent Life in the Universe*, written for Lily by long-time collaborator Jane Wagner, won a Tony Award for best actress in a play, the Drama Desk Award, and the Outer Circle Critic's Award.

urania

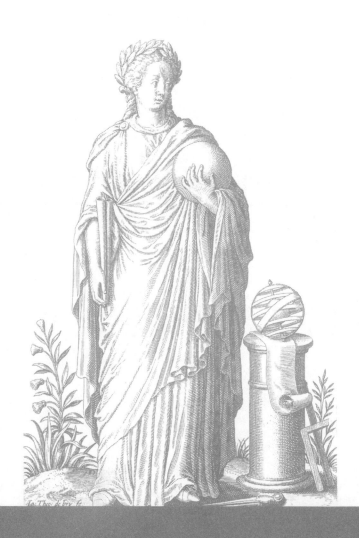

muse of astronomy and science

"In Ixtili Yollotl: Face and Heart"

May our ears
hear
what nobody
wants to hear

may our eyes
see
what everyone
wants to hide

may our mouths
speak
our true faces
and hearts

may our arms
be branches
that give shade
and joy

let us be a drizzle
a sudden storm
let us get wet
in the rain

let us be the key
the hand the door
the kick the ball
the road

let us arrive
as children
to this huge
playground:

the universe

FRANCISCO X. ALARCÓN

Snake Poems: An Aztec Invocation

Urania, the Muse of Astronomy and Science, stirs our musings and our imagination. Her name comes from the Greek word *ouranos* ("all of the Heavens"—or sky). She is present at every discovery, invention, insight, original thought, creative impulse, and "aha" experience. Urania instills wonder, awe, and curiosity within us. She opens our imagination to see possibilities, visions, and images that motivate us to take action and follow our desires to manifest what has heart and meaning for us.

The most beautiful thing we can experience is the mysterious. It is the source of all true art and science.
ALBERT EINSTEIN

Urania motivates the timeless philosophical questions we ask ourselves: Who am I? Are we alone in the Universe? Why do we live? Why do we suffer? Is death the end? What can we know? Why is there evil? What can we hope for? What ought we do? How should we live? What is love? Are there other galaxies and other intelligences in the universe? What is the purpose or mission of the human species? Is there a God? What are dreams? Where do they come from? This Muse sparks the questions that go beyond what we know.

Urania is the ultimate explorer of frontiers, unknown territories, and uncharted questions and mysteries. She has motivated all the great explorations, from those of Columbus and Magellan to the descent to the ocean's depths of Jacques Cousteau to the moon landing with Edgar Mitchell. Naturalists like Luther Burbank, Mary Treat, Rachel Carson, and John James Audubon have also been strongly influenced by this Muse. Urania partners with every Mount Everest climb, Antarctic exploration, and groundbreaking scientific discovery, new invention, or medical breakthrough. Her presence is with us in every ecological matter, scientific exploration, and business endeavor. She is the force of inquiry that allows us to see distinctions and similarities. Urania inspires innovation and enables us to create new concepts and invent devices. Her desire is to bring us clarity, honest facts, objective exploration, and consistent wonder in the face of mystery. She is tenacious in her focus and discipline to discover, uncover, and recover what is lost, forgotten, or unimagined.

Urania is the master problem-solver; and ignites the initiative for us to create breakthroughs from our breakdowns or blocked problematic circumstances. Her commitment is to stay open to the unthinkable—to trust synchronicity, unexpected coincidences, and random inexplicable events. She dismisses nothing prematurely and considers everything as relevant unless proven otherwise. Urania trusts the inner impulses or wonder-

BRINGING URANIA INTO YOUR LIFE

Write your own invocation to bring
Urania into your life:

Invocation

O Urania, explorer of frontiers,
Enhance my capacity for vision,
 inquiry, and innovation.
Bring the spirit of discovery
 and exploration into my life.
Open me to all that I have
 not considered.
Guide me to join others in
 creative collaboration.
May we pioneer what will
 serve the greater good.

ings that are guided by no apparent logic. Her goals are to always discover and challenge the impossible through rigorous discipline, attention, and concentration. Her questions are always: What if? Would it be possible? What will happen next? How does this work? What have I dismissed? Where am I attached? What have I not considered? How will this help? She is the Muse who inspired scientists like Albert Einstein, Jocelyn Bell Burnell, Chien Shiung Wu, Lewis Thomas, and Neils Bohr.

Urania haunts us until we manifest our life dreams or we have left a creative contribution that will help to serve our families, organizations, and communities. She is the one who knows that different aspects of astronomy, ecology, physics, computers, business, mathematics, mysticism, spirituality, and science fiction are not separate entities but bring together—each contained within the others—all explorations of the mystery waiting to be merged into human awareness. Through sustained wonder, curiosity, and discipline, Urania ignites within us the spirit of adventure, exploration, and discovery. Hers is the unspeakable joy of tracking the unknown and startling us with the new interests, ideas, solutions, discoveries, and relationships she brings into our lives.

Urania's essential presence is found at the heart voice of the ancient Alaskan saying: "The inhabitant of the Universe is never seen. . . . It has a gentle voice like a woman, a woman so fine and gentle that even children become afraid. What it says is, 'Be not afraid of the Universe.'"

"HOW POETRY COMES TO ME"

It comes blundering over the
Boulders at night, it stays
Frightened outside the
Range of my campfire
I go to meet it at the
Edge of the light.

GARY SNYDER

MAKE A MUSE COLLAGE OR BULLETIN BOARD FOR URANIA

I've put my genius into my life; I've only put my talent into my works. OSCAR WILDE (1854–1900)

REFLECTIONS:

> *When we try to pick out anything by itself,*
> *we find it tied to everything else in the Universe.*
> JOHN MUIR, NATURALIST

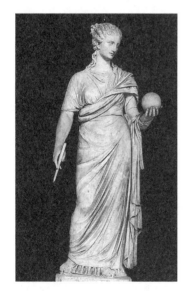

Urania, with her globe and stylus, prepares to explore creative ideas and the world's mysteries.

1. Go outside and look at the stars. Ask Urania, the Muse of Astronomy and Science, to help you with any problem or creative endeavor that you are most concerned about now. Spend half an hour deeply listening to your internal creative process and guidance as you look at the stars. Take an action on any insights or solutions given.

Ah, not to be cut off,
Not through the slightest partition
Shut out from the law of the stars.
The inner—what is it?
If not intensified sky,

Hurled through with birds and deep
With the winds of homecoming.

RAINER MARIA RILKE

2. Visit Project Muse scholarly journals online. The John Hopkins University Press, in collaboration with the Milton S. Eisenhower Library, has created one of the first ventures of its kind. Project Muse provides worldwide, networked subscription access to the full text of the press's forty-plus scholarly journals in the humanities, social sciences, and mathematics. Website: http://muse.jhu.edu/.

3. Read the following Upanishad story. Write down what you consider your light to be in the world.

Yajnavalkya [was] the sage of the king's court. The king asked him one day, "By what light do human beings go out, do their work and return?" "By the light of the sun, the sage answered." "But when the light of the sun is extinguished, by what light do human beings go out, do their work and return?" "By the light of the moon," the sage answered. "And when the moon is extinguished, man works by the stars, and when they are quenched, by the light of fire." "And when the light of the fire itself is put out," the king asked, "By what light then can they do their work and still live?" The sage replied, "By the light of the self."

· Read scientist Arthur Zajonc's book *Catching the Light: The Entwined History of Light and Mind.*

· Read *A Beginner's Guide to Constructing the Universe: The Mathematical Archetypes of Nature, Art, and Science,* by Michael S. Schneider.

· Read *Silent Spring,* by Rachel Carson.

4. What science fiction writers or films have inspired you in positive creative ways? (Ray Bradbury, Isaac Asimov,

URANIA'S PRESENCE IN SCIENCE

· Pythagoras, ancient philosopher and mathematician, took delight in perfect circles and relating musical scales to the planets.

· Carl Sagan, throughout his career, argued for the importance of searching for signs of extraterrestrial life. At Cornell University, he pioneered the new field of exobiology—the study of possible alien biochemistry and life forms.

· Alexander Bell invented the telephone by thinking of the ear's internal structure and attempting to re-create its structure. Thus, the telephone!

· What are you inventing?

There are ways of spreading light, to be the candle or the mirror that reflects it.

EDITH WHARTON

Uranian explorations:
THE MUSES IN THEIR CORRESPONDENCES

Note Sphere	Heavenly Order	Angelic Order	Muse	Song Mode	Level of Inspiration
A	Fixed Stars	Seraphim	Urania	Praise	Spirit
G	Saturn	Cherubim	Polyhymnia	Hymn	Spirit
F	Jupiter	Thrones	Euterpe	Gaiety	Soul
E	Mars	Dominions	Erato	Desire	Soul
D	Sun	Principalities	Melpomene	Dance	Soul
C	Venus	Powers	Terpsichore	Rhythm	Body
B	Mercury	Virtues	Calliope	Voice	Body
A	Moon	Archangels	Clio	Song	Body
(Silent)	Earth	Angels	Thalia	(Instrument)	Spirit

Robert Sardello's synthesis of the musicians and astrologers who were still influenced by the Renaissance and the Uranian imagination. Giorgio Anselmi, in his *De Musica* (1434), the Spanish musician Ramis de Pareja, in his *Musica Practica* (1482), and others, related the Muses to the nine choirs of angels, to notes of the musical scale, to heavenly spheres, to styles of song, and defined the aspect of the human being most subject to each Muse.

Arthur C. Clark, Ursula Le Guin, Madeleine L'Engle, Frank Herbert, and others?) Science fiction has been a creative tool used to solve problems in imaginative ways.

- Write a science fiction short story about how to solve one of the important ecological issues that is significant for you at this time.

- Visit a planetarium. Create a teaching story or poem about one of the planets, or how you would sustain

planet Earth; plant a tree; conserve water; on a weekly
walk, take a trash bag and pick up litter.

5. Work with these Six Universal Steps to Problem-Solving
 with a current problem you have.

Six Universal Steps to Problem-Solving

1. Identify the problem ("problem" comes from the root
 word "probe"):

 a. according to your own personal and professional
 needs

 b. according to organizational and institutional needs

 c. according to the significant needs of others
 involved

2. Creatively brainstorm at least ten possible solutions
 to the problem. Don't edit. Come up with five to ten
 possible solutions. If I cannot come up with at least
 five options, I am not being as creative as I need to be.

3. From the list you created in step 2, select the three most
 workable solutions at this point in time.

4. Negotiate with others involved to reach a consensus on
 the single most workable solution. This is the place of
 consensus/majority rule, the place of making agree-
 ments, commitments to one solution.

5. Create and implement a plan to carry out the consensus
 decision reached in step 4 (who, where, when, and
 how). Assign tasks of responsibility and accountability.

6. Set up a time frame in which to review how the solution
 is working or how it needs to be refined.

This poem refers to the credo of excellence that Urania requires:

"JACK PATTON"

Jack Patton, Commander of rakers in the hay field,
Jack Patton, General of my thirteenth summer,
Jack Patton cursing me on hot afternoons when I
stop to gulp tepid water from a canvas bag.
Jack Patton scolding me to make another round
while others leave the field, making me drive
the old gray team until I scream in tears and rage.

"If you do it, do it right," he says.
Stuck it out all summer, face burned black,
behind numb from rake seat, arms stiff tugging lines,
stuck it out too tired to eat at noon, too tired
to wash for supper, stuck it out and hated him.

"If you do it, do it right," he said.
Wished him all manner of evil:
Lord, give him loose bowels squatting in a ditch
before the President of the United States.
Lord, make him have pimples on his face the size of horse turds.
Lord, let his penis fall off, be eaten by a million flies.

All my life remembering, "If you do it, do it right."

PEGGY SIMSON CURRY
Graining the Mare: The Poetry of Ranch Women

6. What inventors, pioneers, explorers, discoverers, and unusually creative people have you most admired historically and currently? (People like Thomas Edison, Jonas Salk, Amelia Earhart, Margaret Mead, Sylvia Earle, Bill Gates, et al.) In your Muse Journal, create short biographical sketches or poems or gather favorite quotes or sayings by those pioneering people who have inspired you.

Read Howard Gardner's invaluable book, *Creating Minds: An Anatomy of Creativity Seen through the Lives of Freud, Einstein, Picasso, Stravinsky, Eliot, Graham, and Gandhi.*

Pierre and Marie Curie.

At thirty-five, Pierre Curie had already discovered "Curie's Law," relating to coefficients of magnetic attraction, when he became captivated by Marie Sklodowska who was visiting Paris from Poland. Within a few months, he asked her to marry him and live with him in Paris. Working together, they discovered the elements polonium (named after Poland by Marie) and radium. They shared the 1903 Nobel Prize. In 1911, Marie received the Nobel Prize for Chemistry.

<div align="right">

CHARLES HOBSON

Parisian Encounters: Great Loves and Grand Passions

</div>

"GOD'S WORLD"

> *O world, I cannot hold thee close enough!*
> *Thy winds, thy wide grey skies!*
> *Thy mists, that roll and rise!*
> *Thy woods, this autumn day, that ache and sag*
> *And all but cry with colour! That gaunt crag*

To crush! To lift the lean of that black bluff!
World, World, I cannot get thee close enough!

Long have I known a glory in it all,
 But never knew I this;
 Here such a passion is
As stretcheth me apart,—Lord, I do fear
Thou'st made the world too beautiful this year;
My soul is all but out of me,—let fall
No burning leaf; prithee, let no bird call.

 EDNA ST. VINCENT MILLAY

urania in the modern world

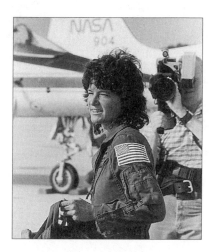

SALLY RIDE, FIRST U. S. WOMAN ASTRONAUT

Sally Kristen Ride was born on May 26, 1951, in Encino, California (near Los Angeles). At twenty-seven, she was a Ph.D. candidate looking for postdoctoral work in astrophysics when she read about programs for astronauts in the Stanford University newspaper. More than eight thousand men and women applied that year to the space program. Thirty-five were accepted, six of whom were women. One was Sally Ride.

Dr. Sally Ride became the first American woman in space on the shuttle *Challenger*'s 1983 mission. She was preparing for her third mission when *Challenger* exploded in 1986. When training was suspended, she moved to NASA headquarters in Washington, D.C., where she became assistant to the NASA administrator for long-range planning. She created the Office of Exploration and produced a report on the future of the space program, "Leadership and America's Stature in Space."

Dr. Ride retired from NASA in 1987 to become a Science Fellow at Stanford University. After two years, she was named Director of the California Space Institute and professor of physics at the University of California, San Diego, where she pursues one of her heartfelt crusades, encouraging young women in science and math.

conclusion

continuing along the mythological path

"LEVITATION WITH BABY"

The Muse bumped
against my window this morning.
No one was at home but me
and the baby. The Muse said
there was room on her back for two.

MARILYN NELSON WANIEK

I hope this book has inspired you to explore and connect with
the creative forces and the feminine principle that each Muse
represents. As you have worked through each chapter and cre-
ated your own Muse Journal, you have most likely assembled a
creative representation of your own private literature. I hope
that you continue the practice of using your journal and asking
yourself often what it is that you learn or discover from your
Muse Journal about your own creativity and authenticity. I hope
that, depending on your background, you will continue to orig-
inate additional historical and contemporary examples of the
Muses that are not found in this book to your Muse Journal.

As I mentioned at the beginning of the book, Yeats best de-
scribed what one learns from one's creative exploration of the
Muses when he wrote: "To speak of one's emotions without fear,
or moral ambition, to come out from under the shadow of the
men's minds, to forget their needs, to be utterly oneself that is
all the Muses care for."

The primary function of the Muses is to reveal how our au-

FOR MORE INFORMATION ON THE MUSES

- Visit "Rediscovering Our Muses" on the Internet: www.geocities.com/~webwinds.com/thalassa/muses1.htm.

Read:
- *The Muses,* edited by Gail Thomas
- *Marry Your Muse,* by Jan Phillips
- *Archetypal Dimensions of the Psyche,* by Marie-Louise von Franz
- *The Alphabet Versus the Goddess,* by Leonard Shlain

thenticity and creativity can support the evolutionary process and spiritual needs of our time. Psychologist Carl Jung proposed that the feminine principle reclaimed within every man and woman would create the intermediary bridge needed to reconcile the existing human needs and collective learnings surrounding the unsolved conflicts, dualities, polarities, and oppositions present within the human psyche.

Jung also believed that the Muses' favorite horse, Pegasus, would be another important bridging symbol of our time. He saw Pegasus as a symbol of the positive instinctual force of the subconscious that signals the unification or synthesis of polarities and oppositions. Pegasus comes from the Greek word *pegae,* geyser, or "to draw forth water." The essential symbol of the feminine has long been water, *aqua femina.* Whenever Pegasus's hooves drew water, the Muses would always appear. Many said that those who drink from the mysterious waters are endowed with poetic inspiration, loving expression, and heightened creativity.

The development of the feminine principle, the intermediary within every man and woman, allows us to creatively stay with conflicting impulses long enough for the two opposing forces to teach the other something and produce an insight that serves both.

To view the elements of our life in a paradoxical manner is to draw forth, like Pegasus, a whole series of creative possibilities until a hidden unity is revealed. When we access the Muses consciously as an intermediary force, we begin to mobilize our true creative work, which Robert Johnson identifies as: dimming our egos, befriending our shadows, and committing to building a bridge between polarities, conflicts, and oppositions in order to create solutions that go beyond a compromise or quarrel.

In his book *Owning Your Own Shadow: Understanding the Dark Side of the Psyche,* Johnson further states that our creative challenge today is to transform opposition into paradox, which is to allow both sides of an issue, or pair of opposites, to exist in equal dignity and worth until the hidden unity is revealed.

The feminine principle symbolized by the Muses, and the positive instinctual force of the subconscious revealed by Pegasus, are the creative emissaries that can assist us in discovering solutions that can support and move us forward individually and collectively. Our unobstructed creativity is the ambassador connected to the mystery that allows us to release the vision, wisdom, and love needed to create a future world that works for everybody.

Portuguese poet Sophia de Mello Breyer suggests a possible twenty-first-century invocation for us to use to access the Muses: "Muse, teach me the song revered and primordial. The song for everyone believed by all." This is the time to remember and honor what is revered and primordial in order to create an opening to join in life's greatest creative endeavor—to create the song or vision for everyone, believed by all.

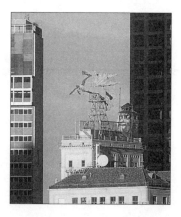

citations and permissions

The author and publishers gratefully acknowledge permission to use quotations and images from the works listed here. In every case, diligent efforts were made to obtain permission to reprint selections from previously published works. In a few instances, permission was not received in time for formal acknowledgment. Any omissions will be corrected in future printings upon notification.

The Invocations for each chapter were written by the author, Angeles Arrien.

contents

Julia Alvarez, from *Something to Declare* (New York: Algonquin Books, 1988) pp. 148–49. Reprinted by permission of Julia Alvarez.

The New Dictionary of Thought (New York: Standard Book Company, 1960), quotations from Shelley (p. 489); (Voltaire (p.53); Wilde (p. 623); Carlyle (p. 430).

Agnes De Mille, *The Life and Work of Martha Graham* (New York: Random House, 1991), p. 239, quotation from Martha Graham.

preface

Frank T. Rios, "Invocation," from *The Outlaw Bible of American Poetry,* edited by Alan Kaufman (New York: Thunder's Mouth Press, 1999), p. 565.

The Derivation of the Word MUSE. Reprinted by permission of Michael A. Chapman. Michael A. Chapman is a consultant on collaborative processes and cocreation through his consulting firm, Collaborative Guidance, in Marin County, California, (415) 388-3888. His current work is on decoding and revealing deeper meanings of the English alphabet and on the nature of the English language as a holographic system embodying thought. Two of his sources are: *Origins,* by Eric Partridge (New York: Greenwich House,

1983), and *The Barnhart Concise Dictionary of Etymology*, edited by Robert K. Barnhart (New York: HarperCollins, 1995).

introduction

Paul Henry Lang, from *A Pictorial History of Music* (New York: Norton, 1960).

Rainer Maria Rilke, "Turning Point," from *The Selected Poetry of Rainer Maria Rilke*, edited and translated by Stephen Mitchell. Copyright © 1982 by Stephen Mitchell. Reprinted by permission of Random House, Inc. P. 135.

Hesoid, *Theogony*, translated by Hugh G. Evelyn-White, edited by Gregory R. Crane. The Perseus Project, http: www.perseus.tufts.edu, August 1999.

Julia Alvarez, *Something to Declare* (New York: Algonquin Books, 1988), pp. 148–9. Reprinted by permission of Julia Alvarez.

Jean Garrigue, "Upon the Intimation of Love's Mortality." First published in *Poetry Northwest* (Box 354330, University of Washington, Seattle, WA 98195), June 1964. Reprinted by permission of *Poetry Northwest*.

Charles Hobson on Louise Colet and Gustave Flaubert, from *Parisian Encounters: Great Loves and Grand Passions* (San Francisco: Chronicle Books, 1994). Reprinted by permission.

mnemosyne

Plato, from *The Great Books of the Western World*, edited by Robert Maynard Hutchins (Chicago: Encyclopedia Britannica, 1952), vol. 7.

Susan Mitchell (p. 203), and Garrett Hongo (p. 105), from *The Poet's Notebook: Excerpts from the Notebooks of Contemporary American Poets*, edited by Stephen Kuusisto, Deborah Tall, and David Weiss (New York: Norton, 1995).

Tennessee Williams (p. 21), and T. S. Eliot (p. 75), from *Sunbeams: A Book of Quotations*, edited by Sy Safransky (Berkeley: North Atlantic Books, 1990).

bell hooks, from *Marry Your Muse: Making a Lasting Commitment to Your Creativity: A Complete Course in Creative Expression*, by Jan Phillips (Wheaton, IL: Quest Books, 1997), p. 28.

J. D. McClatchy, from *The Poet's Notebook: Excerpts from the Notebooks of Contemporary American Poets*, edited by Stephen Kuusisto, Deoborah Tall, and David Weiss (New York: Norton, 1995), p. 160.

Amy Tan, from www.starlingtech.com/quotes/qsearch.cgi (Quote Search).

Lucille Clifton, "i am accused of tending to the past." Copyright © 1991 by Lucille Clifton. Reprinted from *Quilting: Poems 1987–1990* with the permission of BOA Editions, Ltd., 260 East Ave., Rochester, NY 14604.

X. J. Kennedy, from *The Poet's Notebook: Excerpts from the Notebooks of Contemporary American Poets*, p. 121.

Joy Harjo, "Remember," from *She Had Some Horses* (New York: Thunder's Mouth Press, 1983). Copyright © 1983 by Thunder's Mouth Press. Appears by permission of the publisher, Thunder's Mouth Press.

Joy Harjo, "We cannot escape" and "I was the first," from *The Poet's Notebook*, pp. 81, 87.

About Joy Harjo, from Bill Moyers, *The Language of Life: A Festival of Poets* (New York: Doubleday, 1995), p. 159.

calliope

Robert Frost, from *Sunbeams: A Book of Quotations*, edited by Sy Safransky (Berkeley: North Atlantic Books, 1990), p. 148.

Mary Oliver, from *The Poet's Notebook*, p. 229.

Stephen Dunn, from *The Poet's Notebook*, p. 25.

Shirlene Holmer, from Jan Phillips, *Marry Your Muse* (Wheaton, IL: Quest Books, 1997), p. 222.

Rita Dove, "Canary," from *Grace Notes* (New York: Norton, 1989). Copyright © 1989 by Rita Dove. Used by permission of the author and W. W. Norton & Company, Inc.

Rita Dove, from *The Poet's Notebook*, p. 13. Reprinted by permission of Rita Dove.

clio

Eileen Gregory, from *The Muses*, edited by Gail Thomas (Dallas: Dallas Institute Publications, a.k.a. The Pegasus Foundation, 1994). Reprinted by permission.

James Olney, from Functional and Dysfunctional Autobiography: John Boorman's *Hope and Glory* and Terence Davies's *Distant Voices, Still Lives*, by David Lavery, article on website: www.mtsu.edu/~dlavery/funchys.htm, June 1999.

Li-Young Lee, from *The Language of Life*, p. 256.

Donald Hall, from *The Poet's Notebook: Excerpts from the Notebooks of Contemporary American Poets*, edited by Stephen Kuusisto, Deborah Tall, and David Weiss (New York: Norton, 1995), p. 68.

Alice Walker, "Women," from *Revolutionary Petunias* (New York: Harcourt Brace, 1973). Reprinted by permission. Copyright © 1973 Alice Walker.

Annie Dillard, from *The Writing Life* (New York: HarperCollins, 1989), p. 68.

Piero Ferrucci, from *Inevitable Grace* (Los Angeles: Tarcher, 1990), p. 62.

Anselm Hollo, from *The Poets Notebook*, p. 89.

Lorna Dee Cervantes, "Beneath the Shadow of the Freeway," from *No More Masks! An Anthology of Twentieth-Century American Women Poets*, edited by Florence Howe (New York: HarperCollins, 1993), p. 309.

Edmund Spencer, from *Sixteenth Edition Bartlett's Familiar Quotations: A Collection of Passages*, edited by J. Barlett and J. Kaplan (Boston: Little Brown, 1992), 154:4.

Doris Kearns Goodwin. Excerpt reprinted with the permission of Simon and Schuster from *Wait Till Next Year*, by Doris Kearns Goodwin. Copyright © 1997 by Blithedale Productions. Pp. 255–56.

Washington Post reviewer from www.lecturenow.com/People/Doris Goodwin.htm.

ερατο

Charles Simic, from *The Poet's Notebook*, p. 278.

William B. Yeats, "Those Images," from *The Collected Poems* (New York: Macmillan, 1961).

Nguyen Chi Thien, from *The Vintage Book of Contemporary World Poetry*, edited by J. D. McClatchy (New York: Vintage Books, 1996), p. 423.

Anonymous fable "Love." © 1998 Alexander J. Donn, adonn@ uwashington.edu. Reprinted by permission.

Robert Bly, "A Third Body," from *Loving a Woman in Two Worlds* (Garden City, NY: Dial Press, 1985). Reprinted by permission of Robert Bly.

Willa Cather, from *Robert's Favorite Quotes*. www.garden.net/users/robert/ quotes.html.

Manyōshū selections from *The Penguin Book of Women Poets*. Carol Cosman, Joan Keefe, and Kathleen Weaver, editors. (New York: Penguin, 1979), pp. 71, 72, 73.

Eduardo Galeano, "The House of Words," from *The Book of Embraces,* translated by Cedric Belfrage (New York: Norton, 1991), p. 21.

López Velarde, from *The Double Flame: Love and Eroticism,* by Octavio Paz, translated by Helen Lane (New York: Harcourt Brace Jovanovich, 1995), p. 81.

Diane Ackerman, *A Natural History of Love* (New York: Random House, 1994), p. 336.

Unfinished sonnet, from *100 Great Poems by Women,* edited by Carolyn Kizer (Hopewell, NJ: Ecco Press, 1995), p. 10.

Stephen Dunn, from *The Poet's Notebook,* p. 27.

Luci Tapahonso, "Raisin Eyes," from *Saanii Dahataal: The Women Are Singing: Poems and Stories*, by Luci Tapahonso. Copyright © 1993 Luci Tapahonso. Reprinted by permission of the University of Arizona Press.

Neeli Cherkovski, "The Woman at the Palace of the Legion of Honor," from *The Outlaw Bible of American Poetry,* edited by Alan Kaufman (New York: Thunder's Mouth Press, 1999), p. 496. Reprinted by permission of Neeli Cherkovski.

euterpe

Ezra Pound, from *The Most Brilliant Thoughts of All Time,* by John M. Shanahan (New York: Cliff Street Books, 1999), p. 260.

Shari Lewis, from Shari Lewis in the Lamb Light: www.grandtimes .com/mags/lambchop.html.

Pablo Casals, from *Joys and Sorrows,* by Pablo Casals (New York: Simon & Schuster, 1970), p. 11.

Victor Hugo, from www.geocities.com/paris/leftbank/9640/index .html.

Henry David Thoreau, from *A Writer's Journal* (New York: Dover, 1960) (Journal 1857).

Charles Hobson, from *Parisian Encounters: Great Loves and Grand Passions* (San Francisco: Chronicle Books, 1994).

Sylvia Plath, from *No More Masks!,* edited by Florence Howe (New York: HarperCollins, 1993), p. 221.

Susanne Langer, from *The New York Public Library Book of Twentieth Century American Quotations,* edited by Stephen Donadio, Joan Smith, Susan Mesner (New York: Warner Books, 1992), p. 61.

Richard Heinberg, Howard Gardner, and Charles Keil, from *Yes! A Journal of Positive Futures* (winter 1998/99), pp. 37, 38. Reprinted by permission.

Lisel Mueller, "Romantics." Reprinted by permission of Louisiana State University Press from *Waving from Shore,* by Lisel Mueller. Copyright © 1989 by Lisel Mueller.

Johannes Brahms, letter to Clara Schumann, from *Brahms: His Life and Times,* by Paul Holmes (London: Baton Press, 1984), p. 151.

Alonzo Quavehema, from *Brahms: His Life and Times* (London: Baton Press, 1984), p. 151.

melpomene

Renascence and Other Poems, "Sorrow," by Edna St. Vincent Millay (New York: Dover Publications, Inc. 1991), p. 25.

Simone Weil, from *The Poet's Notebook,* p. 257.

Plutarch, from *Citizen Summitry,* edited by Don Carlson and Craig Comstock (Los Angeles: Tarcher, 1986), p. 306.

David Whyte, "The Well of Grief," from *Where Many Rivers Meet* (Langley, WA: Many Rivers Publishing, 1990). Reprinted by permission.

Forgiveness prayer, Buddhist prayer given to author by Karen Roeper.

Azim Khamisa, from "Azim Khamisa: Preventing Youth Violence," by Gail Bernice Holland, *Connections* 7 (May 1999), p. 3 (published by the Institute of Noetic Sciences, Sausalito, CA).

Joyce Carol Oates, "Biography as Pathography," from *Where I've Been, and Where I'm Going* (New York: Plume, 1999), p. 145.

Czeslaw Milosz, from *The Witness of Poetry* (Cambridge: Harvard U. Press, 1983), p. 9.

Marion Woodman, from *Addiction to Perfection: The Still Unravished Bride* (Toronto: Inner City Books, 1982).

Adrienne Rich, from *The Poet's Notebook: Excerpts from the Notebooks of Contemporary American Poets,* edited by Stephen Kuusisto, Deborah Tall, and David Weiss (New York: Norton, 1995), p. 167.

Professor Francis Sejersted on Aung San Suu Kyi, from website: www.nobel.se/essays/heroines/index.html anchor 81733.

polyhymnia

Judy Chicago, "Merger Poem: A Vision for the Future." © Judy Chicago 1979. Reprinted by permission. Through the Flower, 101 N. Second St., Belen, NM 87002.

Julia Cameron, from an interview on New Dimensions Radio, 800-935-8273; www.newdimensions.org.

Carolyn Forché, from *The Language of Life: A Festival of Poets,* by Bill Moyers (New York: Doubleday, 1995), p. 131.

Rumi, from *Unseen Rain: Quatrains of Rumi,* edited by Coleman Barks and John Moyne (Putney, VT: Threshold Books, 1986), p. 37.

Vassar Miller, "Prayer to My Muse," from *If I Had Wheels or Love: Collected Poems of Vassar Miller* (Dallas: Southern Methodist University Press, 1991). Reprinted by permission.

Etty Hillesum, from *Marry Your Muse: Making a Lasting Commitment to Your Creativity: A Complete Course in Creative Expression,* edited by Jan Phillips (Wheaton, IL: Quest Books, 1997), p. 119.

Jane Kenyon, from *The Language of Life: A Festival of Poets* (New York: Doubleday, 1995), p. 219.

Three Sample Speeches from *The World's Great Speeches,* edited by Lewis Copeland (New York: Dover, 1958), Contents page.

"The Thunder, Perfect Mind," from *The Nag Hammadi Library in English* (San Francisco: HarperSanFrancisco, 1990), pp. 302, 303.

Lucille Clifton, "Turning." © 1987 by Lucille Clifton. Reprinted from *Good Woman: Poems and a Memoir, 1969–1980,* with the permission of BOA Editions, Ltd., 260 East Ave., Rochester, NY 14604.

Terpsichore

Agnes de Mille, from *Creating Minds,* by Howard Gardner (New York: Basic Books, 1993), p. 307.

Isadora Duncan, from *The Dance Experience,* edited by M. H. Nadel and C. G. Nadel (New York: Praeger, 1970), p. 32.

Martha Graham, from *Life & Times of Martha Graham.*

Faith Whittlesey on Fred Astaire and Ginger Rogers, from www.panix.com/~tnp/dance/d-quotes.htm.

www.geocities.com/heartland/3382/dquotes.html.

Gabrielle Roth, *Maps to Ecstasy* (San Rafael, CA: New World Library, 1989), p. 31.

Origin of the polka, www.centralhome.com/ballroomcountry/polka.htm. © 1996–1999 John Barendrecht. All rights reserved.

Latin American dances, from *History of Latin-American Dancing,* by Don Herbison-Evans. www.linus.socs.uts.edu.au. Technical report 323, Basser Department of Computer Science, University of Sydney, 1999.

Diane Wakoski, "Moneylight." Copyright © 1991 by Diane Wakoski. Reprinted from *Medea the Sorceress* with the permission of Black Sparrow Press, Santa Rosa, CA.

Daisy Zamora, "Celebration of the Body," from *Life for Each*, bilingual ed., translated by Dinah Livingstone (London: Katabasis, 1994). Reprinted by permission.

Thalia

Red Skelton, from "Online Newshour Remembering Red Skelton, September 17, 1997." Transcript.

Steve Martin, spoken at U.S. Annual Comedy Arts Festival in Aspen, CO, 1999.

Charlie Chaplin, from website: www.mistral.co.uk/hammerwood /chaplin.htm.

Robert R. Provine, "Laughter," *American Scientist* (January–February 1996). www.sigmaxi.org/Amsci/Articles/96articles/Provine-R-S .html. Reprinted by permission.

A. Mookerjee, from *Ritual Art of India* (New York: Thames and Hudson, 1985).

Neoplanet interview with Robin Williams, www.zdnet.com/yil/ content/mag/9702/robin/rw970115.html.

Great Quotations to Inspire and Motivate You: Laughter. www.cyber-nation .com/victory/quotations/subjects/quotes-laughter.html. Japanese proverb.

Eight-year-old girl, Boise, Idaho, poem given to author.

Jane Wagner, *The Search for Signs of Intelligent Life in the Universe* (New York: Harper and Row, 1986), p. 19. Copyright © 1986 by Jane Wagner Inc. Reprinted by permission of HarperCollinsPublishers, Inc.

Urania

Francisco X. Alarcón, "In Ixtili Yollotl/Face and Heart," from *Snake Poems: An Aztec Invocation* (San Francisco: Chronicle Books, 1992), p. 119. Reprinted by permission of Chronicle Books, © 1992.

Albert Einstein, from *A Beginner's Guide to Constructing the Universe*, by Michael S. Schneider (New York: HarperCollins, 1994).

Alaskan Saying, spoken at a gathering at the First Nations Learning Center, University of British Columbia, Vancouver, B.C., Canada.

Gary Snyder, "How Poetry Comes to Me," from *No Nature: New and Selected Poems* (New York: Pantheon Books, 1992).

Oscar Wilde, from *The Most Brilliant Thoughts of All Time*, by John M. Shanahan (New York: Cliff Street Books, 1999), p. 257.

Rainer Maria Rilke, from *The Enlightened Heart,* edited by Stephen Mitchell (New York: Harper & Row, 1989), p. 144.

Information on Pythagoras, Carl Sagan, Alexander Bell, from "Did You Know," Associated Press, March 1997. www.astr.ua.edu/4000ws/didyouknow.1.html.

Upanishad story, from *Creativity and Conformity,* by Clark Moustakas (New York: Van Nostrand, 1967), p. 124. (Out of print.)

Edith Wharton, from *The Most Brilliant Thoughts of All Time*, by John Shanahan (New York: Cliff Street Books, 1999).

Robert Sardello, *Uranian Explorations: The Muses in their Correspondences,* from *The Muses*, edited by Gail Thomas (Dallas: Dallas Institute Publications, a.k.a. Pegasus Foundation, 1994), p. 17. Reprinted by permission.

Six Universal Steps to Creative Problem-Solving: Reprinted by permission of the author, Angeles Arrien.

Peggy Simson Curry, "Jack Patton," from *Graining the Mare: The Poetry of Ranch Women* (Layton, UT: Gibb Smith, 1994), p. 38. Reprinted by permission of Michael Curry.

Charles Hobson, from *Parisian Encounters: Great Loves and Grand Passions* (San Francisco: Chronicle Books, 1994). Reprinted by permission.

Edna St. Vincent Millay, "God's World," from *Renascence and Other Poems* (New York: Dover, 1991).

conclusion

Marilyn Nelson Waniek, "Levitation with Baby." Reprinted by permission of Louisiana State University Press from *Mama's Promises: Poems by Marilyn Waniek*. Copyright © 1985 by Marilyn Nelson Waniek.

Sophia de Mello Bryer, from *The Vintage Book of Contemporary World Poetry,* edited by J. D. McClatchy (New York: Vintage Books, 1996), p. 5.

images: sources and credits

contents

AKG London, Theodor de Bry (1528–1598). Detail of Mnemosyne. From a series depicting the Nine Muses. Copper engraving, Archiv f. Kunst & Geschichte Berlin Collection.

Erich Lessing/Art Resource, NY, painting by Eustache Le Sueur (1617–1655). Detail of the Muse Calliope. From the Chambre des Muses, Louvre, Paris, France.

Erich Lessing/Art Resource, NY, painting by Eustache Le Sueur (1617–1655). Detail of Clio from The Muses Clio, Euterpe, and Thalia. From the Chambre des Muses, Louvre, Paris, France.

Scala/Art Resource, NY, painting by Eustache Le Sueur (1617–1655). Detail of Erato from The Muses Melpomene, Erato, and Polyhymnia. From the Chambre des Muses, Louvre, Paris, France.

Erich Lessing/Art Resource, NY, painting by Eustache Le Sueur (1617–1655). Detail of Euterpe from The Muses Clio, Euterpe, and Thalia. From the Chambre des Muses, Louvre, Paris, France.

Scala/Art Resource, NY, painting by Eustache Le Sueur (1617–1655). Detail of Melpomene from The Muses Melpomene, Erato, and Polyhymnia. From the Chambre des Muses, Louvre, Paris, France.

Scala/Art Resource, NY, painting by Eustache Le Sueur (1617–1655). Detail of Polyhymnia from The Muses Melpomene, Erato, and Polyhymnia. From the Chambre des Muses, Louvre, Paris, France.

Erich Lessing/Art Resource, NY, painting by Eustache Le Sueur (1617–1655). Detail of the Muse Terpsichore. From the Chambre des Muses, Louvre, Paris, France.

Giraudon/Art Resource, NY. Detail of Thalia. Jean Marc Nattier (1685–1766), France.

Erich Lessing/Art Resource, NY, painting by Eustache Le Sueur (1617–1655). Detail of the Muse Urania. From the Chambre des Muses, Louvre, Paris, France.

Introduction

Greek school scene, flute player. © Bettmann/CORBIS.

© Photo RMN—Hervé Lewandowski, Sarchophage des Muses, Louvre.

Louise Colet and Gustave Flaubert, paintings by Charles Hobson. From *Parisian Encounters: Great Loves and Grand Passions by Charles Hobson* © 1994. Published by Chronicle Books, San Francisco. Used with permission.

Alinari/Art Resource, NY, painting by Baldassare Peruzzi (1481–1536). Apollo and the Muses. Galleria Palatina, Palazzo Pitti, Florence, Italy.

Mnemosyne

AKG London, Theodor de Bry (1528–1598), Mnemosyne. From a series depicting the Nine Muses. Copper engraving, Archiv f. Kunst & Geschichte Berlin Collection.

Carlos Dorrien, sculptor. The Nine Muses, granite statues, 1990–1997. Permanently installed at Grounds for Sculpture, New Jersey, 1999. Member of the faculty in the art department at Wellesley College, MA. Reprinted by permission. Photo: Ricardo Barros.

Bulletin Board: Brain Image: Dover Pictorial Archive Series: *Harter's Picture Archive for Collage and Illustration* by Jim Harter, 1978, p. 51. Painted figure (black image): Canyon art. Lower Pecos River, Utah (from photo by Alan Gingritch). Source: Douglas Mazonowicz, *Voices from the Stone Age: A Search for Cave and Canyon Art.* New York: Thomas Y. Crowell, 1974, p. 179.

Bulletin Board Creators: Angeles Arrien, Concept; Twainhart Hill, Creative Project Coordinator; Rita Wood, Art Director; Kris Dickinson, Photography.

Detail of Mother of the Muses, Mnemosyne. From Alexander S. Murray, *Who's Who in Mythology: Classic Guide to the Ancient World.* London: Bracken Books, 1994. An imprint of Studio Editions, Ltd., plate 23.

Alinari/Art Resource, NY, statue of Mnemosyne, Vatican Museums, Vatican State.

Computer Chip. © Bettmann/CORBIS.

Woodcut of human brain. © Bettmann/CORBIS.

Photo of Joy Harjo © William Abranowicz/Art & Commerce.

calliope

AKG London, Theodor de Bry (1528–1598), Calliope. From a series depicting the Nine Muses. Copper engraving, Archiv f. Kunst & Geschichte Berlin Collection.

Poet's Corner—Home Page. Website: www.geocities.com/~spanoudi /poems/index.html.

Erich Lessing/Art Resource, NY, painting by Eustache Le Sueur (1617–1655). The Muse Calliope. From the Chambre des Muses, Louvre, Paris, France.

THE HISTORY OF THE EUSTACHE LE SUEUR
PANELS OF THE NINE MUSES

No real idea of seventeenth-century painting can be had without reference to the great ensembles, which once decorated the walls of newly built Parisian "hotels particuliers." Although dismantled in 1776, the decorations Le Sueur painted for the Hotel Lambert on the Île Saint-Louis are one of the most complete ensembles to survive. His panels consisted of five panels, which formed a concert of nine Muses, and were placed in the alcove of the bedroom of Mme. Lambert de Thorigny. (From: website of the Louvre Museum, Paris, France)

Bulletin Board: Shakespeare: © Bettmann/CORBIS. Film Reel: © CORBIS. Western Folklife Center logo. Western Folklife Center, 501 Railroad St., Elko, NV 89801, (775) 738-7508. Logo designed by Jean Trumbo. Bulletin Board Creators: Angeles Arrien, Concept; Twainhart Hill, Creative Project Coordinator; Rita Wood, Art Director; Kris Dickinson, Photography.

Alinari/Art Resource, NY, statue of Calliope, Vatican Museums, Vatican State.

Emily Dickinson and Walt Whitman photos: © Culver Pictures, Inc., NY.

Page layout and Artist: Rita Wood.

Photo Ragtime. This calliope is one of many automated musical instruments still being manufactured by Ken Caulkins, Ragtime, in Ceres, CA, in the late 1900s. 4218 Jessup Road, Ceres, CA 95307 USA, Tel: 209-667-5525, www.ragtimewest.com. Reprinted by permission.

Photo of Rita Dove © Fred Viebahn, 1757 Lambs Rd., Charlottesville, VA 22901. Reprinted by permission.

clio

AKG London, Theodor de Bry (1528–1598), Clio. From a series depicting the Nine Muses. Copper engraving, Archiv f. Kunst & Geschichte Berlin Collection.

Richard MacDonald, artist. Trumpeter. Life Size Bronze. 6'3" x 54" x 44", completed 1998, Monterey, CA, (831) 655-0424. Reprinted by permission of the artist.

Erich Lessing/Art Resource, NY, painting by Eustache Le Sueur (1617–1655). Detail of Clio from The Muses Clio, Euterpe, and Thalia. From the Chambre des Muses, Louvre, Paris, France.

Bulletin Board: Clio Awards logo: Reprinted by permission. Ernest Hemingway at his typewriter © Hulton-Deutsch Collection/CORBIS. Typewriter: Dover Pictorial Archive Series: *Harter's Picture Archive for Collage and Illustration* by Jim Harter, 1978, p. 10. Bulletin Board Creators: Angeles Arrien, Concept; Twainhart Hill, Creative Project Coordinator; Rita Wood, Art Director; Kris Dickinson, Photography.

Alinari/Art Resource, NY, statue Clio, Vatican Museums, Vatican State.

Photo of Doris Kearns Goodwin © Seth Resnick/CORBIS.

erato

AKG London, Theodor de Bry (1528–1598), Erato. From a series depicting the Nine Muses. Copper engraving, Archiv f. Kunst & Geschichte Berlin Collection.

Henry Miller and Anaïs Nin, paintings by Charles Hobson. From *Parisian Encounters: Great Loves and Grand Passions,* by Charles Hobson © 1994. Published by Chronicle Books, San Francisco. Used with permission.

Scala/Art Resource, NY, painting by Eustache Le Sueur (1617–1655). Detail of Erato from The Muses Melpomene, Erato, and Polyhymnia. From the Chambre des Muses, Louvre, Paris, France.

Bulletin Board: Photo of Mother Teresa from Joanne Firth. Bulletin Board Creators: Angeles Arrien, Concept; Twainhart Hill, Creative Project Coordinator; Rita Wood, Art Director; Kris Dickinson, Photography.

Alinari/Art Resource, NY, statue Erato, Vatican Museums, Vatican State.

Lovers. Early Twentieth-Century Italian Illustration. Carol Belanger Grafton, *Treasury of Book Ornament and Decoration.* Dover Clip Art Series. New York: Dover Publications, 1986.

Photo of Sophia Loren: © Mitchell Gerber/CORBIS.

εuτerpe

AKG London, Theodor de Bry (1528–1598), Euterpe. From a series depicting the Nine Muses. Copper engraving, Archiv f. Kunst & Geschichte Berlin Collection.

Erich Lessing/Art Resource, NY, painting by Eustache Le Sueur (1617–1655). Detail of Eutrepe from The Muses Clio, Euterpe, and Thalia. From the Chambre des Muses, Louvre, Paris, France.

Bulletin Board: Sheet Music: © CORBIS. Schubert: Dover Clip Art Series, *Old-Fashioned Music Illustrations,* New York: Dover Publications, 1990, p. 24. Temptations ticket from Joanne Firth. Bulletin Board Creators: Angeles Arrien, Concept; Twainhart Hill, Creative Project Coordinator; Rita Wood, Art Director; Kris Dickinson, Photography.

Alinari/Art Resource, NY, statue Euterpe, Musei Capitolini, Rome, Italy.

Frederic Chopin and George Sand, paintings by Charles Hobson. From *Parisian Encounters: Great Loves and Grand Passions,* by Charles Hobson © 1994. Published by Chronicle Books, San Francisco. Used with permission.

Flutist Image. Carol Belanger Grafton, *Ready To Use Old-Fashioned Music Illustrations.* Dover Clip Art Series. New York: Dover Publications, Inc., 1990.

Web page of Amazon.com.

Petroglyphs of Flutist in New Mexico. © David Muench/CORBIS

Beverly Sills Application. © CORBIS.

Photo of Beverly Sills. © Hulton-Deutsch Collection/CORBIS.

melpomene

AKG London, Theodor de Bry (1528–1598), Melpomene. From a series depicting the Nine Muses. Copper engraving, Archiv f. Kunst & Geschichte Berlin Collection.

Scala/Art Resource, NY, painting by Eustache Le Sueur (1617–1655). Detail of Melpomene from The Muses Melpomene, Erato, and Polyhymnia. From the Chambre des Muses, Louvre, Paris, France.

Siren Image, Early Twentieth-Century Italian Illustration. Carol Belanger Grafton, *Treasury of Book Ornament and Decoration*. Dover Clip Art Series. New York: Dover Publications, Inc., 1986.

Bulletin Board: Marilyn Monroe photo: ©Hulton-Deutsch Collection/CORBIS. Othello Playbill photo: © Bettmann/CORBIS. Ribbon: Different colored ribbons are used to represent varied causes from child kidnapping, accidents, AIDS, and prisoners' release. Bulletin Board Creators: Angeles Arrien, Concept; Twainhart Hill, Creative Project Coordinator; Rita Wood, Art Director; Kris Dickinson, Photography.

Alinari/Art Resource, NY, statue Melpomene, Vatican Museums, Vatican State.

Photo of Aung San Suu Kyi reading. © Christophe Loviny/CORBIS.

Photo of Aung San Suu Kyi, oval head shot. © Christophe Loviny/CORBIS

polyhymnia

AKG London, Theodor de Bry (1528–1598), Polyhymnia. From a series depicting the Nine Muses. Copper engraving, Archiv f. Kunst & Geschichte Berlin Collection.

Scala/Art Resource, NY, painting by Eustache Le Sueur (1617–1655). Detail of Polymnia from The Muses Melpomene, Erato, and Polyhymnia. From the Chambre des Muses, Louvre, Paris, France.

Photo of Marcel Marceau. © CORBIS.

Bulletin Board: Eleanor Roosevelt photo: © Bettmann/CORBIS. Fanny Wright Image: from *What Every American Should Know About Women's History: 200 Events That Shaped Our Destiny,* by Christine Lunardini. Microphone Image: from *Extraordinary Speeches of the American Century in Our Own Words,* edited by Senator Robert Torricelli and Andrew Carroll. Holbrook, Massachusetts: Adams Media Corporation, 1997, p. 25.

Bulletin Board Creators: Angeles Arrien, Concept; Twainhart Hill, Creative Project Coordinator; Rita Wood, Art Director; Kris Dickinson, Photography.

Alinari/Art Resource, NY, statue Polyhymnia, Museo del Prado, Madrid, Spain.

Copper Canyon Press logo © 1983, calligraphy by Yim Tse. Reprinted by permission of Copper Canyon Press, Post Office Box 271, Port Townsend, WA 98368.

Photo of Oprah Winfrey. © Reuters NewMedia Inc/CORBIS.

Terpsichore

AKG London, Theodor de Bry (1528–1598), Terpsichore. From a series depicting the Nine Muses. Copper engraving, Archiv f. Kunst & Geschichte Berlin Collection.

Photo of Ginger Rogers and Fred Astaire. © Bettmann/CORBIS.

Erich Lessing/Art Resource, NY, painting by Eustache Le Sueur (1617–1655). The Muse Terpsichore. From the Chambre des Muses, Louvre, Paris, France.

Bulletin Board: Modern Dancers in Performance photo: © Bettmann/CORBIS. Bulletin Board Creators: Angeles Arrien, Concept; Twainhart Hill, Creative Project Coordinator; Rita Wood, Art Director; Kris Dickinson, Photography.

Alinari/Art Resource, NY, statue Terpsicore, Vatican Museums, Vatican State.

Photo of Celia Cruz. © Colita/CORBIS.

Photo of Judith Jamison with dancers. © Bettmann/CORBIS.

Photo of Judith Jamison, head shot. © Bettmann/CORBIS.

Thalia

AKG London, Theodor de Bry (1528–1598), Thalia. From a series depicting the Nine Muses. Copper engraving, Archiv f. Kunst & Geschichte Berlin Collection.

Detail: Thalia. The Muse Thalia. Jean Marc Nattier (1685–1766), Paris, Private Collection. Art Resource, NY/Giraudon.

The Fertile Imagination, by Richard Stine. Printed by permission of artist. © 1999 Richard Stine, www.richardstine.com.

Bulletin Board: Charlie Chaplin photo, © Bettmann/CORBIS. Bulletin Board Creators: Angeles Arrien, Concept; Twainhart Hill,

Creative Project Coordinator; Rita Wood, Art Director; Kris Dickinson, Photography.

Alinari/Art Resource, NY, statue Detail of Thalia from photo of Clio, Thalia, and Urania, Vatican Museums, Vatican State.

The Cartoon Bank, cartoon from *The New Yorker* magazine (Hastings, NY: The Cartoon Bank), December 22, 1997, p. 88. © *The New Yorker* Collection, 1997, Frank Modell, from cartoonbank.com. All Rights Reserved.

Photo of Lily Tomlin as Telephone Operator Ernestine. © Bettmann/CORBIS.

Photo of Lily Tomlin, head shot. © Bettmann/CORBIS.

urania

AKG London, Theodor de Bry (1528–1598), Urania. From a series depicting the Nine Muses. Copper engraving, Archiv f. Kunst & Geschichte Berlin Collection.

Erich Lessing/Art Resource, NY, painting by Eustache Le Sueur (1617–1655). The Muse Urania. From the Chambre des Muses, Louvre, Paris, France.

Bulletin Board: Bill Gates photo, © Reuters Newmedia Inc/CORBIS. Amelia Earhart photo, © Bettmann/CORBIS. Bulletin Board Creators: Angeles Arrien, Concept; Twainhart Hill, Creative Project Coordinator; Rita Wood, Art Director; Kris Dickinson, Photography.

Alinari/Art Resource, NY, statue Detail of Urania from photo of Clio, Thalia, and Urania, Vatican Museums, Vatican State.

Pierre and Marie Curie paintings by Charles Hobson. From *Parisian Encounters: Great Loves and Grand Passions,* by Charles Hobson © 1994. Published by Chronicle Books, San Francisco. Used with permission.

Photo of Sally Ride. © Bettmann/CORBIS.

conclusion

Photo: Neon Pegasus on top of The Holtze Magnolia Hotel, Dallas, TX. The Pegasus was created in 1934 and, according to the Dallas Convention and Visitor's Bureau, has become a symbol of Dallas. Stock Options/L. Poissenot.

Photo: J. Pinsent. Greek Coin, Pegasus, Aras Files.

photo agencies

AKG London, The Arts and History Picture Library. Tel: 0171-610-6103 Fax: 0171-610-6125; e-mail: enquiries@akg-longon.co.uk; www.akg-london-co.uk.

Art Resource, 65 Bleecker Street, 9th Floor, New York NY 10012. Tel: 212-505-8700; Fax: 212-420-9286; www.artres.com.

Culver Pictures Inc., Photographs. Old Prints. 150 W. 22nd St., #300, New York, NY 10011, 212-645-1672.

CORBIS, 2223 S. Carmelina Ave., Los Angeles, CA 90064. Tel: 310-820-7077; Fax: 310-820-2687.

RMN, Agence photographique de la réunion des musees nationaux, Paris, France. Tel: 011-33-1-40-13-48-00; Fax: 011-33-1-40-13-46-01.

Stock Options, 4602 East Side Avenue, Dallas, TX 75226. Tel: 214-823-6262; Fax: 214-826-6263.

Bibliography

Ackerman, Diane. *A Natural History of Love.* New York: Random House, 1994.

Alarcón, Francisco X. *Snake Poems: An Aztec Invocation.* San Francisco: Chronicle Books, 1992.

Alvarez, Julia. *Something to Declare.* Chapel Hill, NC: Algonquin Books of Chapel Hill, 1998.

Apollodorus. *Gods and Heroes of the Greeks: The Library of Apollodorus.* Amherst: University of Massachusetts Press, 1976.

Archive for Research in Archetypal Symbolism files. C. G. Jung Institute of San Francisco.

Arias, P. E., and M. Hirmer. *A History of 1000 Years of Greek Vase Painting.* New York: Abrams, 1962.

Armitage, M. *Martha Graham: The Early Years.* New York: Da Capo Press, 1995.

Barett, C., ed. *Greek Short Biographies of the World.* New York: Robert McBride, 1929.

Barks, Coleman, and John Moyne, eds. *Unseen Rain: Quatrains of Rumi.* Putney, VT: Threshold Books, 1986.

Barrows, Anita, and Joanna Macy, trans. *Rilke's Book of Hours: Love Poems to God.* New York: Riverhead Books, 1996.

Barthell, Edward E. *Gods and Goddesses of Ancient Greece.* Coral Gables, FL: University of Miami Press, 1971.

Bartlett, J., and J. Kaplan. *Sixteenth Edition Bartlett's Familiar Quotations: A Collection of Passages.* Boston: Little Brown, 1992.

Barzun, Jacques. *Clio and the Doctors: Psycho-History, Quanto-History, and History.* Chicago: University of Chicago Press, 1974.

Beek, Rederich A. G. *Album of Greek Education.* Sydney: Cheriron Press, 1975.

Bell, Robert E. *Women of Classical Mythology—A Bibliographical Dictionary.* Santa Barbara: ABC-CLIO, 1991.

Bender, Sheila. *Writing Personal Essays: How to Shape Life Experiences for the Page.* Cincinnati: Writer's Digest Books, 1995.

Bentley, Eric. *The Life of the Drama.* New York: Atheneum, 1965.

Bieber, M. *The History of the Greek and Roman Theatre.* Princeton, NJ: Princeton University Press, 1939; 2nd ed. 1964.

Bonta, Marcia Myers. *Women in the Field: America's Pioneering Women Naturalists.* College Station, TX: Texas A & M University Press, 1991.

Boswell, Fred. *What Men or Gods Are These? A Genealogical Approach to Classical Mythology.* Metuchen, NJ: Scarecrow Press, 1980.

Browning, Elizabeth Barrett. *Sonnets from the Portuguese.* New York: Dover Publications, 1992.

Brussat, Frederic and Mary Ann. *Spiritual Literacy: Reading the Sacred in Everyday Life.* New York: Touchstone, 1996.

Bullfinch, Thomas. *Myths of Greece and Rome.* New York: Penguin, 1974.

Cameron, Julia. *The Artist's Way: A Spiritual Path to Higher Creativity.* Los Angeles: Tarcher, 1992.

———. *The Vein of Gold: A Journey to Your Creative Heart.* New York: Putnam, 1996.

Campbell, Joseph. *Hero with a Thousand Faces.* Princeton, NJ: Princeton University Press, 1968.

———. *Inner Reaches of Outer Space: Metaphor as Myth and as Religion.* Toronto: St. James Press, 1986.

———. *The Masks of God: Creative Mythology.* New York: Viking, 1968.

———. *Myths to Live By.* New York: Viking, 1993.

Carbone, Ken. *The Virtuoso: Face to Face with 40 Extraordinary Talents.* New York: Stewart, Tabori and Chang, 1999.

Carlson, Don, and Craig Comstock, eds. *Citizen Summitry: Keeping the Peace When It Matters Too Much to Be Left to Politicians.* Los Angeles: Tarcher, 1986.

Carotenuto, Aldo. *Eros and Pathos: Shades of Love and Suffering.* Toronto: Inner City Books, 1989.

Casals, Pablo. *Joys and Sorrows.* New York: Simon and Schuster, 1970.

Chaudhuri, Haridas. *The Philosophy of Love.* New York: Routledge and Kegan Paul, 1987.

Chekhov, Michael. *To the Actor on the Technique of Acting.* New York: Harper and Row, 1953.

Chicago, Judy. *The Dinner Party.* New York: Penguin, 1996.

Chinen, Allan. *Waking the World: Classic Tales of Women and the Heroic Feminine.* New York: Tarcher, 1996.

Clifton, Lucille. *Quilting: Poems 1987–1990.* Los Angeles: Tarcher, 1991.

Conway, Jill Ker. *When Memory Speaks: Reflections on Autobiography.* New York: Knopf, 1998.

Copeland, Lewis, ed. *The World's Great Speeches.* New York: Dover, 1958.

Cosman, Carol, Joan Keefe, and Kathleen Weaver, eds. *The Penguin Book of Women Poets.* New York: Penguin, 1979.

Cousineau, Phil, ed. *Prayer at 3 A.M.: Poems, Songs, Chants.* San Francisco: HarperSanFrancisco, 1995.

cummings, e. e. *1913–1962: Complete Poems.* New York: Harcourt, Brace, Jovanovich, 1972.

de Mille, Agnes. *The Life and Work of Martha Graham.* New York: Random House, 1991.

Dickinson, Emily. *Selected Poems.* New York: Dover, 1990.

Dillard, Annie. *The Writing Life.* New York: HarperCollins, 1989.

Dofflemyer, John C. *Muses of the Ranges.* Lemon Cove, CA: Dry Crik Press, 1991.

Donadio, Stephen, Joan Smith, Susan Mesner, and Rebecca Davison, eds. *The New York Public Library Book of 20th Century American Quotations.* New York: Warner, 1992.

Downing, Christine. *The Goddess: Mythological Images of the Feminine.* New York: Crossroad Press, 1981.

———. *Myths and Mysteries of Same-Sex Love.* New York: Continuum, 1989.

Edinger, Edward F. *The Eternal Drama: The Inner Meaning of Greek Mythology.* Boston: Shambhala, 1994.

Eliot, Alexander. *Myths.* New York: McGraw-Hill, 1976.

Eliot, T. S. *Complete Poems and Plays.* New York: Harcourt, Brace, and World, 1962.

———. *The Family Reunion.* New York: Harcourt, Brace, 1939.

Emerson, Ralph Waldo. *Poems.* Boston: Houghton, Mifflin, 1904.

Feinstein, David, and Stanley Krippner. *The Mythic Path: Discovering the Guiding Stories of Your Past—Creating a Vision for Your Future.* New York: Tarcher/Putnam, 1997.

Ferlinghétti, Lawrence. *A Far Rockaway of the Heart.* San Francisco: New Directions, 1977.

Ferrucci, Piero. *Inevitable Grace.* Los Angeles: Tarcher, 1990.

Frazer, J. G. *The Golden Bough: A Study in Magic and Religion.* New York: Macmillan, 1971.

French, A. P., ed. *Centenary Volume.* Cambridge: Harvard University Press, 1979.

Fritz, Robert. *Creating: A Guide to the Creative Process.* New York: Fawcett Columbine, 1991.

Frost, Robert. *Complete Poems of Robert Frost.* New York: Holt, Rinehart and Winston, 1967.

———. *Selected Letters of Robert Frost.* Ed. Laurance Thompson. New York: Holt, Rinehart, 1964.

Galeano, Eduardo. *The Book of Embraces.* Trans. Cedric Belfrage. New York: Norton, 1991.

Gardner, Howard. *Creating Minds.* New York: Basic Books, 1993.

Goodwin, Doris Kearns. *Wait Till Next Year: A Memoir.* New York: Simon and Schuster, 1997.

Grafton, Carol Belanger. *Ready To Use Old-Fashioned Music Illustrations.* Dover Clip Art Series. New York: Dover, 1990.

———. *Treasury of Book Ornament and Decoration.* Dover Clip Art Series. New York: Dover, 1986.

Graves, Robert. *The Greek Myths.* New York: Braziller, 1957.

———. *New Larousse Encyclopedia of Mythology.* New York: Putnam, 1968.

Hamlyn, Paul. *Larousse Encylopedia of Mythology.* New York: Prometheus Press, 1959.

Harding, M. Esther. *Women's Mysteries: Ancient and Modern.* New York: Harper Colophon Books, 1976.

Harns, Valerie. *The Inner Lover.* Berkeley: Shambala, 1993.

Harvey, Andrew, and Anne Baring. *The Divine Feminine.* Berkeley: Conari Press, 1996.

Havelock, E. A. *The Literate Revolution in Greece and Its Cultural Consequences.* Princeton, NJ: Princeton University Press, 1982.

Heinberg, Richard. "Music of the (Hemi)Spheres." *Yes! A Journal of Positive Futures* (Winter 1998/99), pp. 37, 38.

Hillman, James. *Anima.* Dallas: Spring, 1985.

———. *The Thought of the Heart and Soul of the World.* Dallas: Spring, 1993.

Hobson, Charles. *Parisian Encounters: Great Loves and Grand Passions.* San Francisco: Chronicle Books, 1994.

Hollis, James. *Swamplands of the Soul: New Life in Dismal Places.* Toronto: Inner City Books, 1996.

———. *Tracking the Gods: The Place of Myth in Modern Life.* Toronto: Inner City Books, 1995.

Holmes, Paul. *Brahms: His Life and Times.* London: Baton Press, 1984.

Hope, Jane. *The Secret Language of the Soul.* San Francisco: Chronicle Books, 1997.

Howe, Florence, ed. *No More Masks! An Anthology of Twentieth-Century American Women Poets.* New York: HarperCollins, 1993.

Hutchins, Robert Maynard, ed. *The Great Books of the Western World.* 54 vols. Chicago: Encyclopedia Britannica, 1952.

———. *The Great Books of the Western World,* 2nd ed. Chicago: Encyclopedia Britannica, 1990.

Huxley, Aldous. *Music at Night and Other Essays.* Salem, NH: Ayer, 1931; reprint series.

Johnson, Robert. *Owning Your Own Shadow: Understanding the Dark Side of the Psyche.* San Francisco: HarperCollins, 1991.

Johnson, Thomas H., ed. *The Complete Poems of Emily Dickinson.* Boston: Little, Brown, 1960.

Jones, Shirley Ann, ed. *Simply Living: The Spirit of the Indigenous People.* Novato, CA: New World Library, 1999.

Jordan, Teresa, ed. *Graining the Mare: The Poetry of Ranch Women.* Layton, UT: Gibbs Smith, 1994.

Kaufman, Alan. *The Outlaw Bible of American Poetry.* New York: Thunder's Mouth Press, 1999.

Keats, John. *The Complete Poetical Works and Letters of John Keats.* New York: Houghton, Mifflin and Company, 1899.

Kingsley, Peter. *In the Dark Places of Wisdom.* Inverness, CA: The Golden Sufi Center, 1999.

Kizer, Carolyn, ed. *100 Great Poems by Women.* Hopewell, NJ: Ecco Press, 1995.

Koch, Kenneth. *Making Your Own Days: The Pleasures of Reading and Writing Poetry.* New York: Scribner, 1998.

Kuusisto, Stephen, Deborah Tall, and David Weiss, eds. *The Poet's Notebook: Excerpts from the Notebooks of Contemporary American Poets.* New York: Norton, 1995.

Lang, Paul Henry. *A Pictorial History of Music.* New York: Norton, 1960.

Lao Tzu. *Tao Te Ching.* Trans. D. C. Lau. New York: Penguin, 1980.

Lawrence, D. H. *Complete Poems.* New York: Viking, 1994.

Lorenz, Konrad. *King Solomon's Ring.* New York: Simon and Schuster, 1952.

Luke, Helen. *Kaleidoscope: The Way of the Woman and Other Essays.* New York: Parabola Books, 1992.

Lunardini, Christine. *What Every American Should Know About Women's History: 200 Events That Shaped Our Destiny.* Holbrook, MA: Adams Media, 1997.

McClatchy, J. D. *The Vintage Book of Contemporary World Poetry.* New York: Vintage, 1996.

McGrayne, Sharon Bertsch. *Nobel Prize Women in Science: Their Lives, Struggles and Momentous Discoveries.* New York: Birch Lane Press, 1993.

Macrone, Michael. *By Jove! Brush Up Your Mythology.* New York: Harper-Collins, 1992.

Macy, Joanna, trans. *Rilke's Book of Hours: Love Poems to God.* New York: Riverhead Books, 1996.

Maltman, Chauncey. *Best Loved Poems of Best Loved Poets.* Chicago: Fountain Press, 1959.

Mara, Thalia. *To Dance, To Live.* New York: Dance Horizons, 1977.

Marth, Ann, and Dorothy Myers. *Goddesses in World Mythology.* Santa Barbara: ABC-CLIO, 1993.

May, Rollo. *The Cry for Myth.* New York: Norton, 1991.

———. *Love and Will.* New York: Norton, 1969.

Metzger, Deena. *A Sabbath Among the Ruins.* Berkeley: Parallax Press, 1992.

Millay, Edna St. Vincent. *Renascence and Other Poems.* New York: Dover, 1991.

Miller, Ernest R. *Harvest of Gold.* Norwalk, CT: C. R. Gibson, 1973.

Milosz, Czeslaw. *The Witness of Poetry.* Cambridge: Harvard University Press, 1983.

Mitchell, Stephen, ed. *The Enlightened Heart.* New York: Harper and Row, 1989.

Mookerjee, Ajit. *Ritual Art of India.* New York: Thames and Hudson, 1985.

Moustakas, Clark. *Creativity and Conformity.* New York: Van Nostrand, 1967.

Moyers, Bill. *The Language of Life: A Festival of Poets.* New York: Doubleday, 1995.

Mulcahy, Susan. "The Cult of Ruth." *Vanity Fair,* November 1999.

Murray, Alexander S. *Who's Who in Mythology: Classic Guide to the Ancient World.* Middlesex, U.K.: Senate, 1998.

Nadel, M. H., and C. G. Nadel. *The Dance Experience.* New York: Praeger, 1970.

Neihardt, John G. *Black Elk Speaks.* Lincoln, NE: University of Nebraska Press, 1979.

The New Dictionary of Thought. New York: Standard Book Company, 1960.

Oates, Joyce Carol. *Where I've Been, and Where I'm Going.* New York: Plume, 1999.

O'Donohue, John. *Eternal Echoes.* New York: Cliff Street Books, 1999.

Oliver, Mary. *House of Light.* Boston: Beacon Press, 1990.

——. *New and Selected Poems.* Boston: Beacon Press, 1992.

——. *A Poetry Handbook: A Prose Guide to Understanding and Writing Poetry.* New York: Harcourt Brace & Company, 1994.

Page, James K., Jr. *Rare Glimpse into the Evolving Way of the Hopi.* Washington, D.C.: Smithsonian Institute Press, 1975.

Paris, G. *Pagan Grace: Dionysos, Hermes, and Goddess Memory in Daily Life.* Trans. Joanne Mott. Dallas: Spring 1998.

Paz, Octavio. *The Double Flame: Love and Eroticism.* Trans. Helen Lane. New York: Harcourt, Brace, Jovanovich, 1995.

——. *The Other Voice: Essays on Modern Poetry.* Trans. Helen Lane. New York: Harcourt, Brace, Jovanovich, 1991.

——. *The Siren and the Seashell.* Austin, TX: University of Texas Press, 1976.

Phillips, Jan. *Marry Your Muse: Making a Lasting Commitment to Your Creativity. A Complete Course in Creative Expression.* Wheaton, IL: Quest Books, 1997.

Pinsent, John. *Greek Mythology.* New York: P. Bedrick Books, 1982.

"Poetry in America." *Poets and Writers* 27, 7 (April 1999).

Raffe, W. G. *Dictionary of Dance.* New York: Barnes, 1964.

Rilke, Rainer Maria. *The Selected Poetry of Maria Rainer Rilke.* Ed. and trans. Stephen Mitchell. New York: Vintage, 1982.

Roberts, Elizabeth, and Elias Amidon, eds. *Prayers for a Thousand Years.* San Francisco: HarperSanFrancisco, 1999.

Robinson, James M., ed. *The Nag Hammadi Library in English.* San Francisco: HarperSanFrancisco, 1990.

Rodwell, J. M., trans. *The Koran.* New York: Dutton, 1977.

Rose, H. J. *A Handbook of Greek Mythology Including Its Extension to Rome.* London: Dutton, 1981.

Rossetti, Christina. *Goblin Market and Other Poems.* New York: Dover, 1994.

Roth, Gabrielle. *Maps to Ecstasy.* San Rafael, CA: New World Library, 1989.

Saba, Umberto. *The Stories and Recollections of Umberto Saba.* Trans. Estelle Gilson. Riverdale-on-Hudson, NY: Meadow Press, 1992.

Safransky, Sy. *Sunbeams: A Book of Quotations.* Berkeley: North Atlantic Books, 1990.

Schefold, Karl. *Myth and Legend in Early Greek Art.* New York: Abrams, 1966.

Schneider, Michael S. *A Beginner's Guide to Constructing the Universe.* New York: HarperCollins, 1994.

Shanahan, John M. *The Most Brilliant Thoughts of All Time.* New York: Cliff Street Books, 1999.

Shantideva, Acharya. *A Guide to the Bodhisattva's Way of Life.* Trans. Stephen Batchelor. Dharamsala, India: Library of Tibetan Works and Archives, 1979; reprint 1981.

Shlain, Leonard. *Alphabet Versus the Goddess: The Conflict Between Word and Image.* New York: Viking, 1998.

———. *Art and Physics: Parallel Visions in Space, Time, and Light.* New York: Quill/William Morrow, 1991.

Singer, June. *Seeing Through the Visible World: Jung, Gnosis, and Chaotic Systems.* San Francisco: Harper and Row, 1990.

Snodgrass, Susan. "Heroes and Martyrs." *Art in America* (November 1998), pp. 92–95.

Snyder, Gary. *No Nature: New and Selected Poems.* New York: Pantheon, 1992.

Stafford, William. *The Way It Is: New and Selected Poems.* St. Paul, MN: Graywolf Press, 1998.

Stapleton, Michael. *The Illustrated Dictionary of Greek and Roman Mythology.* New York: Bedrock Books, 1986.

Sturdevant, Cathie Glenn. *The Laugh and Cry Movie Guide: Using Movies to Help Yourself Through Life's Changes.* Larkspur, CA: LightSpheres, 1998.

Thomas, Gail, ed. *The Muses.* Dallas: Dallas Institute Publications, a.k.a. Pegasus Foundation, 1994.

Thomas, Lewis. *The Lives of a Cell: Notes of a Biology Watcher.* New York: Bantam, 1975.

Thoreau, Henry David. *A Writer's Journal.* New York: Dover, 1960 (Journal 1857).

Turner, E. G. *Athenian Books in the 5th and 4th Centuries B.C.* Inaugural lecture delivered at University College, London, 22 May, 1951. 2nd ed. London: Published for the college by H. K. Lewis, 1977.

Von Franz, Marie-Louise. *Archetypal Dimensions of the Psyche.* Boston: Shambhala, 1994.

Wagner, Jane. *The Search for Signs of Intelligent Life in the Universe.* New York: Harper and Row, 1986.

Walker, Pete. *The Tao of Fully Feeling.* Lafayette, CA: Azure Coyote, 1995.

Walsh, Roger. *Essential Spirituality.* New York: Wiley, 1999.

Wells, H. G. *The Outline of History: Being a Plain History of Life and Mankind.* Ed. Raymond Postgate. Garden City, NY: Garden City Books, 1961.

Whyte, David. *Where Many Rivers Meet.* Langley, WA: Many Rivers Press, 1990.

Woodman, Marion. *Addiction to Perfection: The Still Unravished Bride.* Toronto: Inner City Books, 1982.

Wyatt, Thomas, and N. J. Dawood, trans. *The Koran.* New York: Penguin, 1990.

Wylie, C. *Brice Marden, Work of the 1990s: Paintings, Drawings, and Prints.* New York: Distributed Art, 1998.

Yeats, W. B. *The Collected Poems.* New York: Macmillian, 1961.

Zajonc, Arthur. *Catching the Light: The Entwined History of Light and Mind.* New York: Oxford University Press, 1993.

websites

Albin, Kira. Shari Lewis in the Lamb Light, 1999. www.grandtimes .com/mags/lambchop.html.

American Comedy Institute, 1999. www.comedyinstitute.com.

Dunkle, Roger. Introduction to Greek Tragedy. Brooklyn College Core Curriculum Series. academic.brooklyn.cuny.edu/classics/ tragedy.htm.

Fideler, David. Reviving the Academy of the Muses. //cosmopolis .com/df/academies.html.

Greek Tragedy. www.stemnet.nf.ca/~hblake/tragedy1.html.

The Gutenberg School of Scribes. Great Links for Scribes, 1999. www .renstore.com/articles/GSS/scribelinks.shtml.

Ichimura Manjiro Presents Kabuki for Everyone, 1999. www.fix.co .jp/kabuki/kabuki.html.

Izumo no Kuni. www.netsrq.com/~dbois/okuni.html. Contributed by Florence Prusmack, author of *Khan: A romantic historical novel based on the early life of Ghenghis Khan.*

Kerrie's Memories Quotation Page. www.fn.net/~degood/memory .html.

National Comedy Hall of Fame. www.comedyhall.com/.

National Writing Project Mission Statement, 1999. www-gse.berkeley .edu/Research/NWP/mission.html.

Quotes to Inspire. www.cybernation.com/victory/quotations/subjects/ quotes_danceanddancing.html.

Sagan, Carl, 1934–1996. Scientific American: Explorations: Carl Sagan. www.sciam.com/explorations/010697sagan/010697explorations .html.

Spring, Justin. Soulspeak/Sarasota Poetry Theatre, 1999. PO Box 48955, Sarasota, FL 34277. Tel: 941-366-6468; 24 hr. Tel: 941-966-4280; e-mail: soultalk@aol.com.

Taflinger, Richard F. Sitcom. What It Is, How It Works: The Development and Landmark Forms of Television Comedy, 1999. www.wsu .edu:8080/~taflinge/landmark.html.

Turning Memories Into Memoirs, 1999. 95 Gould Road #11, Lisbon Falls, Maine 04252. Tel: 207-353-5454; e-mail: MEMOIRS@IME .NET. www.turningmemories.com.

Waller, Hal L. Charting the Autobiographies of Mark Twain: Thesis project for the Univeristy of Virginia's American Studies Program, 1999.

about the author

Angeles Arrien is an anthropologist, educator, award-winning author, and the founder and president of the Foundation for Cross-Cultural Education and Research. Arrien is also an international consultant who conducts workshops that address cultural diversity and comparative religions. Her work with multicultural issues, mediation, and conflict resolution has most notably been used by such organizations as the International Rights Commission and the World Indigenous Council.

Arrien has given keynote addresses and presentations for businesses, organizations, and schools such as the Wharton Business School, International Women's Forum, Leadership Institute of Seattle, International Global Learning, American Leadership Forum of Silicon Valley, Motorola Corporation, and Hewlett-Packard Labs. Within the medical philanthropic communities, the Fetzer Institute, Kellogg Foundation, Kaiser Permanente Group, California Pacific Medical Center, and Planetree Foundation of San Francisco have consulted Arrien.

Arrien has also taught extensively in the University of California system at Berkeley, Los Angeles, Irvine, Davis, Santa Cruz, and San Francisco, and is an adjunct professor at two Bay Area graduate schools, the California Institute of Integral Studies and the Institute of Transpersonal Psychology. She has received two honorary doctorate degrees for her work, and is a fellow at the Institute of Noetic Sciences in Sausalito, California. For information on programs or products, visit the website at: www.angelesarrien.com
or write her office:

<div align="center">

Angeles Arrien
P.O. Box 2077
Sausalito, CA 94966

</div>